W9-BHS-491

# DARE TO CREATE

The Joys and Tortures of Learning to Paint

Val de Grâce Books
Napa, California

Copyright © 2018 by Monroe Katz
ALL RIGHTS RESERVED
No part of this work may be reproduced
without the written permission of the publisher.

Published by Val de Grace Books
Printed by Kumkang Printing
Artwork photography by Alan Skinner
Book design by A. Cort Sinnes and Dorothy Carico Smith

First Edition

ISBN 978-0-9976405-3-3

Library of Congress Control Number: 2018950628

# DARE TO CREATE

## The Joys and Tortures of Learning to Paint

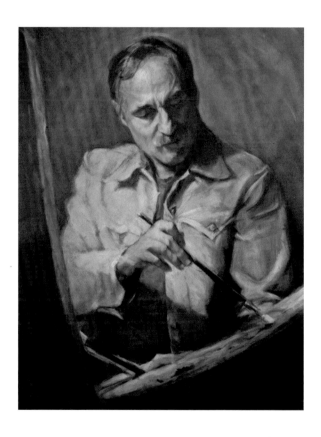

by MONROE KATZ

VAL DE GRÂCE
BOOKS

# Table of Contents

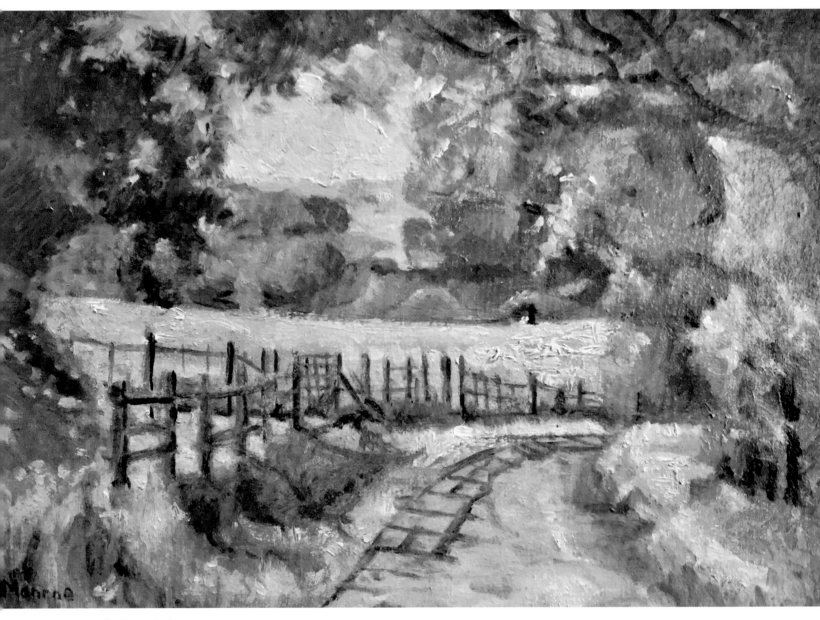

Left: *Henry Road.*

## Welcome Aboard

One evening, at a literary gathering at my publisher's house, it was my turn to give a presentation on a subject of my choice, and I decided to lecture on a topic that has inspired me and, at times, exasperated me. I called the lecture "Rectangles: How They Work for the Artist." With an enlarged acetate-covered photograph of the face of Rembrandt's *The Old Jew* on the easel at my side, I explained how I incorporate rectangles into every painting I produce, whether it's a landscape, portrait or still life. Rectangles connect parts to other parts, echo other shapes, unify background to foreground and serve other functions as well. Rectangles are crucial to understanding Rembrandt's paintings and all of the master paintings I have studied over the years.

This book is a summation of everything I have learned about painting. Rectangles are just one of the topics addressed in this book. Other topics are the expression of feelings, the power of the oblique, the importance of studying sculpture, the order of visual perception, how the artist guides the viewer's eyes through a painting, the importance of squinting, and much more. What you are about to read is not a traditional "how to" book about painting. Rather, it is a book about what an artist should think about before painting and while he paints.

Sprinkled throughout this book are pictures of masterworks and also my drawings, paintings and sculptures. I talk about these works, and I'm not shy about pointing out things that can be improved in my work as I share my artistic journey with you. Mine was a long and very difficult apprenticeship. But thanks to the generosity of my gifted teachers, I came through wiser and more confident in my ability to create and express myself through the medium of painting. It is my fervent hope that my struggles and the techniques and secrets I have learned will speed you on your way, so that one day you too can feel the soaring joy of painting with confidence and ease.

*Monroe Katz*

Napa, California 2018

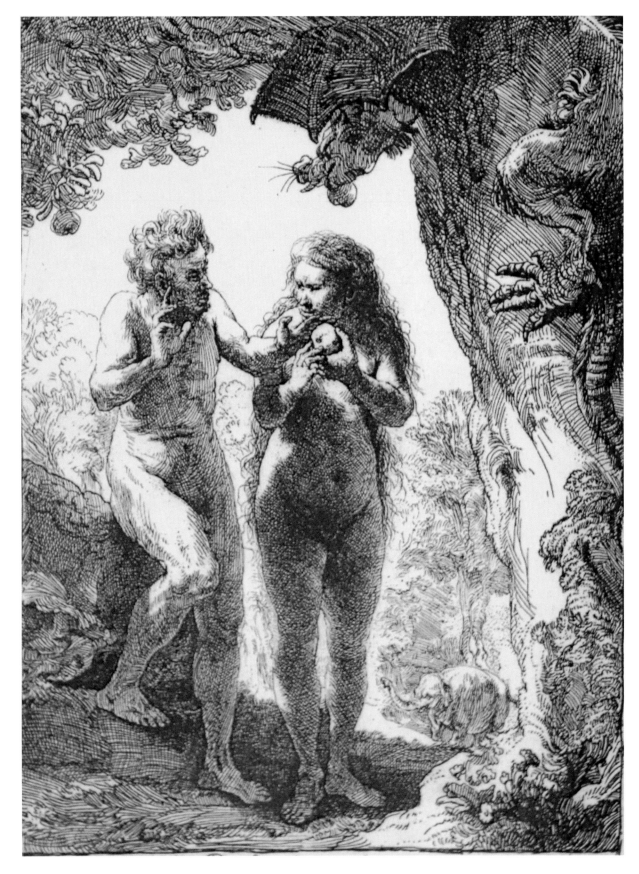

Figure 1.1. *Adam and Eve*, Rembrandt

## Conveying Feeling

"Everyone is born creative; everyone is given a box of crayons in kindergarten. Then when you hit puberty they take the crayons away and replace them with dry, uninspiring books on algebra, history, etc. Being suddenly hit years later with the 'creative bug' is just a wee voice telling you, 'I'd like my crayons back, please.'"

— *Hugh MacLeod (b.1973)*

Rembrandt's art moves me, speaks to me, ignites a fire in me. If I had my choice of any of his works, I'd pick his etching of Adam and Eve (Figure 1.1), which is the high point of my experience with Rembrandt. It is the masterpiece most responsible for my evolution as an artist. I'll refer to this etching from time to time. I'm referring to it now, not so much to dazzle and possibly intimidate you as to show you that everyone needs a hero. Rembrandt is my hero. Maybe in your case it's Monet, O'Keefe, Warhol or Rockwell. We need to shoot for the moon.

The job of an artist is to convey emotion, to move the viewer as Rembrandt moves me. How does he do it? First of all, he has to have something to say. Many things are said — or at least suggested — in *Adam and Eve*, which we'll get to later. The

artist must find his own way to say what he has to say in paint, pencil or clay but he has to be in a proper frame of mind, not as someone painting by the numbers, but as a passionate artist, playing, relaxing, experimenting, agonizing over subject matter, daring, failing, cutting free, trusting his or her inner voice, being in the ring rather than in the grandstand.

I want to share with you what Rembrandt taught me and how I applied it to my work. I'm hoping that along the way you will find your own artistic voice.

And now to work.

Evoking feelings begins with the first mark you place on a sheet of paper. Let's review the basics. My life-drawing classes begin with one-minute gesture drawings on newsprint. As I have

discovered over the years, these warm-up exercises are important, but they can be frustrating if you choose the wrong approach. If you try to draw what the model looks like rather than what he or she is doing you'll barely have enough time to flip over your sheets of paper and sketch crude lines before the model changes his or her pose. My approach is to speedily slash fluid lines onto the paper in a devil-may-care manner, wielding my stick of charcoal like Zorro's sword. I believe Rembrandt worked this way when he did the preliminary sketches for his *Adam and Eve* etching. If you draw this way, it will force you to work from the whole to the parts, and not having time for the parts, you'll develop a rhythm to capture the whole.

A proper attitude is important. I started out years ago feeling as if I had two strikes against me. Strike one was my age, 35. Older people have an ego to guard. (Younger people have even bigger egos but seem less perturbed by their mistakes.) Strike two was my profession,

dentistry. Dentists are trained to be precise. At first, my lines were drilled into the paper no matter how hard I tried to make them free-flowing, but after studying Rembrandt's pencil, charcoal and brush drawings, I forced myself to change my two-strike attitude and my demand for precision. It didn't happen overnight, but it happened. No matter how many strikes you have against you, you can still get a hit, even a home run once in a while. Fortunately, I had teachers who patiently nurtured my artistic talent. They cautioned me to not let myself be intimidated by more advanced students, and I caution you to compete only with yourself. With practice, your work will improve.

In these one-minute warm up exercises the body in motion is important, not detail. What your drawings look like is nobody's business but yours, and of course, your teacher's. That's why drawing classes have a big trashcan in the room. At first, you'll probably toss most of your sketches in the trash, but please keep one or two horrible

Figure 1.2. *Gesture in pencil.*

Figure 1.3. *Gesture in pencil.*

Figure 1.4. *Gesture in red crayon.*

Figure 1.5. *Gesture in ink.*

Figure 1.6. *Ink Nude Study.*

Figure 1.7. *Gesture in charcoal.*

ones so you can gauge your progress. I kept a few of those but don't share them.

The first lines you put down may be in the wrong place, and if they're too dark they'll be hard to correct. I've found that it's better to sneak up on a drawing using light lines. Later, you can darken the ones you want to keep. It's also important to try to feel that you're doing what the model is doing. It will help you to understand what you see.

Eventually, your lines will be drawn artistically rather than with a dentist's precision. Here are examples of my gesture drawings in pencil, charcoal, Conté crayon and ink (Figures 1.2 to 1.7). When I draw with a pen, brush or a sharpened stick dipped in ink, I'm not tempted to modify the lines, and the work looks fresher and more appealing. Do you agree?

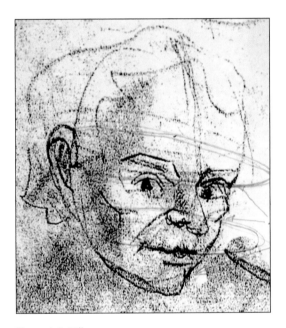

Figure 1.8. *Bill.*

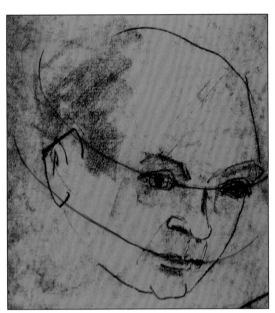

Figure 1.9 *Conductor.*

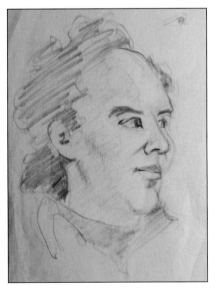

Figure 1.10. *Wild man.*

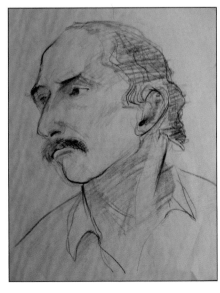

Figure 1.11. *Teacher.*

## Making Room for Depth

Some pre-historic cave artist, short of wall space, got the idea to superimpose one figure over another. At that moment, form over form, the most powerful element of illusion, was born. It was the artistic equivalent of inventing the wheel. It's what gives depth to drawings.

How does the concept of form over form work when drawing a head? If I cut one line across another on a drawing of your head, I can make your ear overlap the side of your head, your upper lip overlap your lower and your nose overlap your cheek, and magically, your head becomes three-dimensional. Here's a quick sketch of a teacher of mine, Bill, who posed one day when a model wasn't available (Figure 1.8). Notice how I superimposed the bag under his left eye — and his chin — over his cheek.

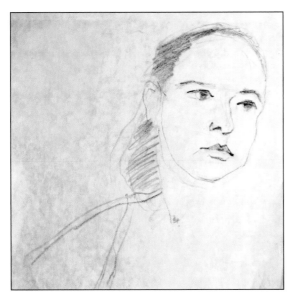

Figure 1.12. *Musician.*

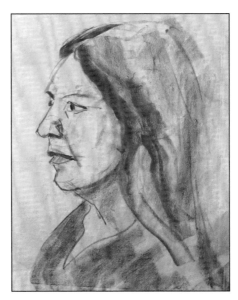

Figure 1.13. *Sheila.*

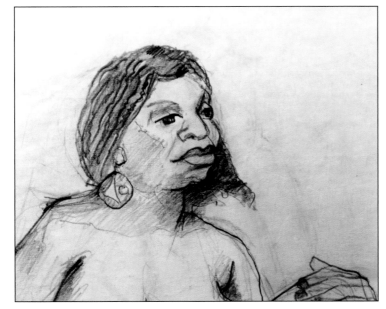

Figure 1.14. *Zwanda.*

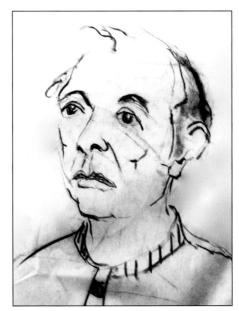

Figure 1.15. *Joe.*

Parallel lines drawn through the eyes and lips of Figure 1.9 are ellipses (circles seen at an angle). They allow me to visualize the eyes and lips wrapping around the front of the face. Look at Rembrandt's etching. See how Eve's eyes and lips wrap around the front of her face? Here are six more heads (Figures 1.10 to 1.15). With practice, you can draw better ones.

Putting lines down loosely and energetically is crucial. Paul Klee said, "A line is a dot out for a walk." Think about lines that way to avoid the rigid, precise ones. Strive for the graceful, curved, free-flowing lines of Rembrandt, which are thick and thin, soft and hard, light and dark, bold and barely discernable, ones expressing feelings.

### Diagonals and Contours

An aid to capturing the vitality of a subject, whether it's a nude, a barn, a boat, a tree or a screwdriver, is to see the large diagonals and their relationship to each other. The diagonal, any line that is not horizontal or vertical, is necessary for vital, vibrant drawing. It suggests motion, and motion suggests life. Figure 1.16 contrasts horizontal and vertical lines with the diagonals of a model in action. The diagonals used in the figures of Adam, Eve and the serpent certainly suggest life and vitality.

An outline of a globe model of Earth is its circular outer shape, essentially a silhouette. Contours are represented by lines of latitude, which curve around the globe and disappear at the edge. It's the same with the model. Contours of the body turn around the form. They can be visualized as turning around imaginary axes, but to enhance the effect, some lines should overlap. If they don't, the viewer will be deprived of a means of imagining forms in space.

Here's how I do a contour drawing: Without charcoal in hand, I study the outlines and contours of the model. Then I pick up my drawing tool

Figure 1.16. *Diagonals of a model in action.*

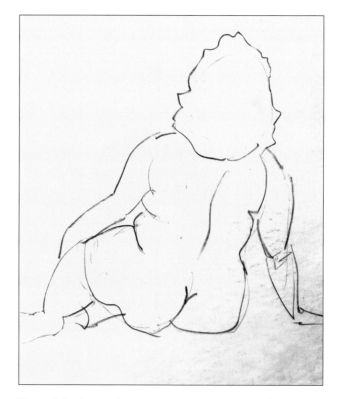

Figure 1.17. *Contour drawing.*

and make believe I'm touching the model with my stick of charcoal that is touching the paper and not looked at. I move my eyes slowly over the forms of the model, coordinate the visual experience with the tactile experience of the tool and stop when I lose that sensation. Sometimes, while doing this exercise, I find myself in a different place, and it's not a bad place to be. It's an exercise in sensitivity that develops the empathy needed to draw or paint. Figure 1.17 is an example of my contour drawing. The following more advanced drawings (Figures 1.18 to 1.22) were done as if I were touching the model with my pencil, but I did look at my marks while making them.

Figure 1.23 is a sketch done in the manner of Luca Cambiaso (1527–1585) who emphasized the sharp-edged planes of the solid figure. Every body part is drawn with fronts and sides. Drawing this way will help you to grasp the concept of planes.

Hands, for example, can be easily rendered in any position if you first draw them, or at least think about them geometrically. In Figure 1.1 see how Rembrandt rendered the top and side of Adam's right thigh with soft-edged planes.

## Who Needs Teachers?

Nothing beats studying one-on-one with a competent, no-nonsense, eagle-eyed master of drawing. You need a teacher until you can be your own teacher, and to maintain your drawing skill, you have to keep drawing from life. I've attended life-drawing sessions in crowded college classrooms where the chatter was about everything except art, and I've hired models who I've had all to myself for three or four hours, but that wasn't the right intellectual atmosphere either. The ideal situation for me is a life-drawing session with four or five like-minded artists in a comfortable setting

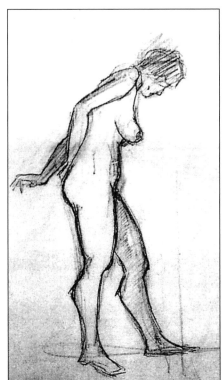

Figure 1.18. *Side view nude.*

Figure 1.19. *Three-quarter view.*

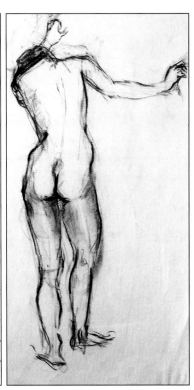

Figure 1.20. *Rear view nude.*

with a coffee pot on the stove, proper lighting, interesting conversation and classical music playing. There is usually someone in the group less advanced than I am and someone whose work I envy. Leonardo da Vinci was right: It's good for art students to be somewhere in the middle of a class, so they can see where they're heading and where they used to be.

Go to the library to study the drawings of the masters. Start with Luca Cambiaso's geometric approach. Study Rembrandt's approach. In his *Woman and Child Descending a Staircase* (Figure 1.24) he has emphasized his subjects' significant features linearly and tonally. You can feel the weight of the child. You can sense the love between mother and child.

Let's look again at Rembrandt's interpretation of Adam and Eve in the Garden of Eden. Other famous artists have their versions of Adam and Eve, but they're pretty boy/pretty girl pictures that don't make you think. None of them pleases me as much as Rembrandt's *Adam and Eve* (Figure 1.1) which captures the moment of temptation. Just by looking, I can tell what Adam and Eve are thinking. How has Rembrandt made this possible? And what does he teach us?

The scene is backlit, with Adam, Eve and the serpent in the shadows and most of the garden bathed in light. The serpent is stretched out ominously in a tree above them. Adam and Eve have rough, fleshy bodies and ordinary faces, which are easy to identify with. Eve has a sly look. Adam looks confused. They could be any couple you

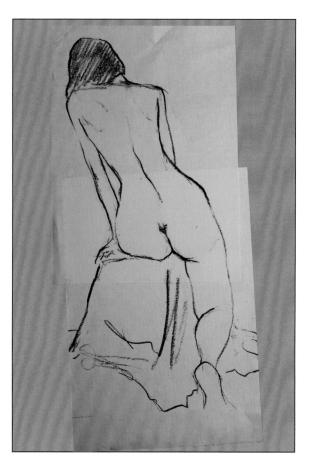

Figure 1.21. *Rear view nude 2.*

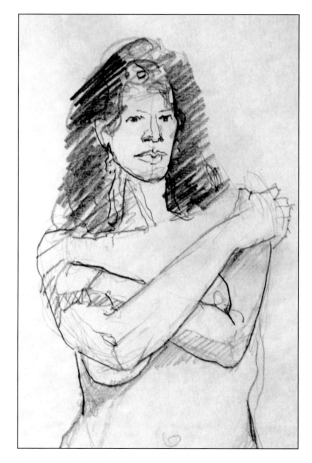

Figure 1.22. *Nude with arms crossed.*

know. Eve is offering the apple. I can sense her persistence. Her expression and body language are saying, "Here, take this." Adam is hesitant. He has a tentative, worried look on his face. His left hand is about to grasp the apple, but his right hand is raised, indicating his trepidation. His expression and body language are saying, "Uh, maybe I'd better not."

The dichotomies of hard and soft, light and shade, good and evil, and naïve earthy people being swayed by a sharply defined devil in disguise make for high drama, which other artists' interpretations lack. On a deeper level, if black represents evil and white represents good, notice that the devil is almost completely black, Eve, less black, and Adam, less yet. Rembrandt's etching is

a work of genius. It teaches me that the portrayal of feelings is what art is all about.

See how other masters brought their figures to life and imbued them with emotion. Study the drawings, etchings and lithographs of Kaethe Kolwitz. Study Rubens' *Old Woman with Pan of Coals* (Figure 8.5). Study my copy of Manet's *Portrait of Stéphane Mallarmé* (Figure 1.25).

Now let's look at capturing physique. Here's a method I use occasionally, which my old sculpture teacher, Joe Query, called "Connections." With light lines, I connect points of interest (landmarks) that line up with each other across a figure. Then I darken the lines I want to keep. For example, in Figure 1.26 the outer edges of the man's pectoralis muscles line up with the inner aspects of his

*Fi*gure 1.23. *Drawing a la Cambiaso.*

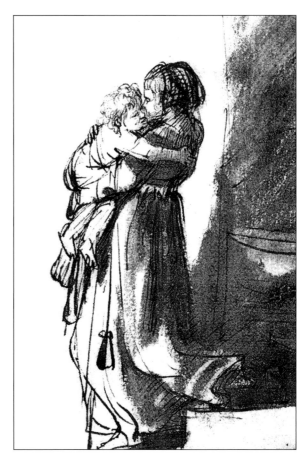

Figure 1.24. *Woman and Child Descending a Staircase* by Rembrandt.

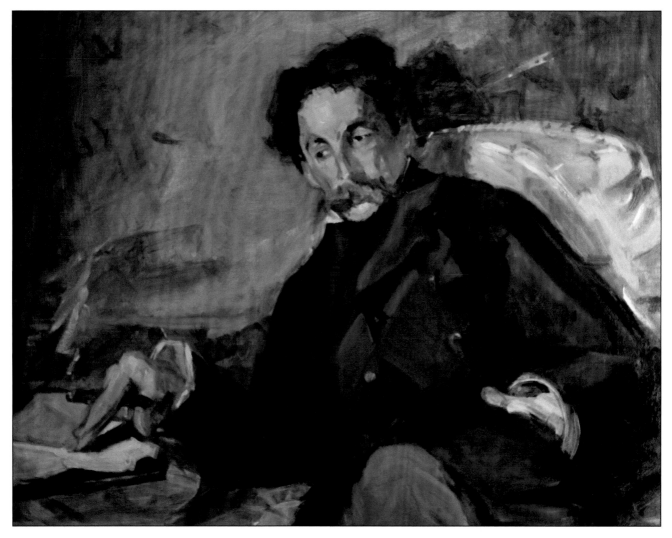

Figure 1.25. My copy of the *Portrait of Stéphane Mallarmé* orignally painted by Manet.

opposite thighs. In Figure 1.28 the iliac crest (the sharply defined angle of the woman's right hip) is lined up with the back of her left arm, and the curve of her left shoulder lines up with her right hip. With enough landmarks and enough lines, I can get an almost photographic image, but I don't spend too much time trying to achieve perfection. Perfect copies are seldom alive. Imperfect ones, drawn at a furious pace, will more likely live and breathe and pulsate on the page. I get the best results when I force myself to visualize, to draw quickly, and to look where I've been but not where I'm going. Feel the exhilaration that I feel when making a magic mark that brings a drawing to life. Compare contour drawing to shadow boxing, and think of your magic marks as knockout punches. (More about Connections in Chapter 9.)

Be daring; don't sacrifice feeling for accuracy, and draw every day. I drew Jim, my oboe-playing friend, on my program while enjoying a concert (Figure 1.27). At the intermission, the man in the seat behind me asked me how many drawings it takes to become proficient. I said, "Five thousand, and I still have a long way to go."

Figure 1.26. *Man standing.*

Figure 1.27. *My friend, Jim, playing the English horn.*

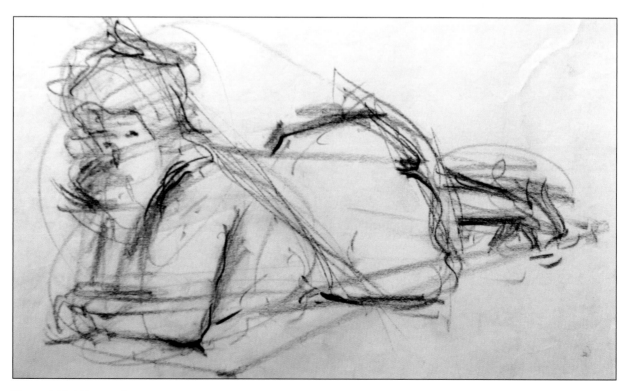

Figure 1.28. *Woman reclining.*

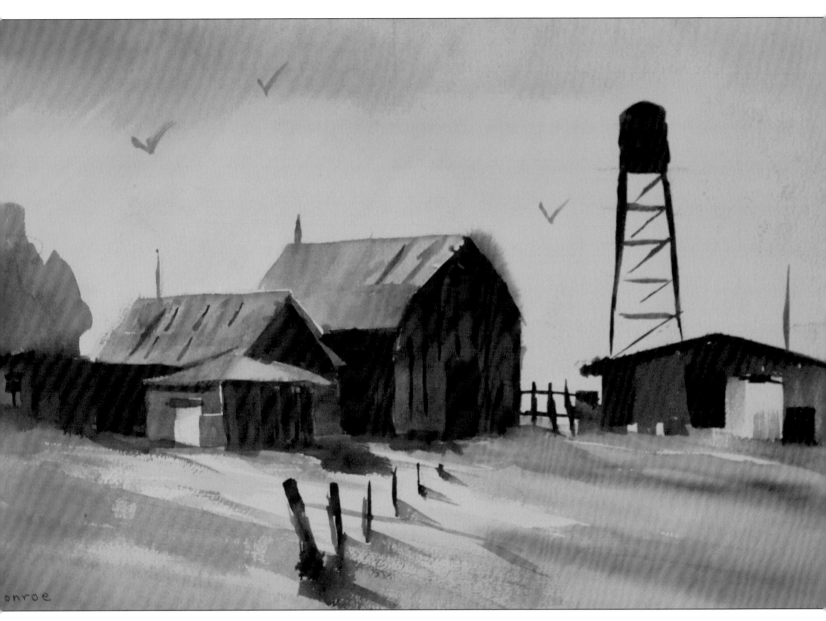

Figure 2.1. *Barn with Diagonal Fence.*

## Composing a Painting

"In my experience, anyone can paint if he doesn't have to… During my apprentice days I felt encouraged by the advice of Winston Churchill … 'Don't be afraid of the canvas.' I have now reached the point where the canvas is afraid of me."

— *Beatrice Lillie (1894–1989)*

I remember being on my teacher's deck alongside a eucalyptus-lined fishy-smelling slough that empties into the Napa River. A snowy egret stood on the mud-bank, and dozens of red-winged blackbirds perched on bulrushes on the far side of the water, their flaming epaulets lending color. Close to the eucalyptus trees were the decaying remnants of an old boathouse and pier. In front of the pier a green rowboat lay at anchor with a lone fisherman in it. The scene was enchanting.

I picked up my Robert Wood watercolor palette, removed its plastic cover, uncapped tubes of watercolor and squeezed the paint into the compartments, arranging the colors with warm yellows and reds separated from cool blues and greens. I felt goose bumps as the colors oozed out, reminding me of the way I felt as a child when I opened a new box of crayons. It's wonderful, I thought, to be able to create, to turn notes into music, words into a poem or paint into a landscape. I dipped my brush into a puddle of color and began to paint.

Wrong. Terribly wrong!

Without planning, there were too many false starts, too many color and value changes, too many scrub-outs, too much time wasted, and all I wound up with was mud.

Painting is easy when you don't know how, but very difficult when you do. Edgar Degas said that, and I have learned the hard way that there's more to art than copying what's in front of me. A camera can do that better than I can. So how do I compose a landscape? I begin before brush touches paper.

Whether I'm on-site or in my studio, I sketch

Figure 2.2.

Figure 2.3.

Figure 2.4.

Figure 2.5.

Figure 2.6.

Figure 2.7.

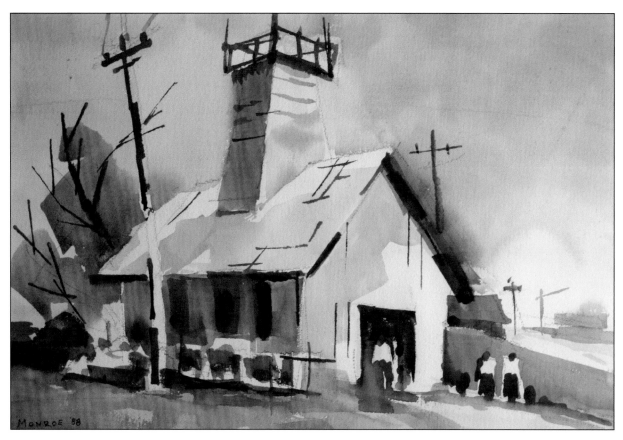

Figure 2.8. *Crow's Nest.*

a few 2 x 3-inch landscapes in pencil. They are called thumbnail sketches, and the few minutes spent on them will save me hours of frustration later. Doing these sketches is a good way to explore and compare placement and values in a hurry. It takes a few seconds to place houses and barns where you want them and a few seconds more to shade-in medium and dark areas.

Balance is important. If the middle of the bottom edge of your thumbnail sketch were sitting on a fulcrum, would the masses balance, would the lights and darks balance, or would the sketch appear to fall to one side? Sometimes all it takes to balance a composition is to reposition a large tree.

## Rules of Three

The rules come in threes.

No. 1: Your thumbnail sketch must have a foreground, mid-ground and background. In the six thumbnail sketches at left, the flat land is the foreground, the mountains are the mid-ground and the sky is the background. Incorporated into these sketches is a value plan. The six possible value plans shown in Figures 2.2 to 2.7 are used only for landscapes and seascapes. They are not satisfactory for figure painting or cityscapes.

No. 2: Foregrounds, mid-grounds and backgrounds of thumbnail sketches must be different sizes: large, medium and small. (They aren't in

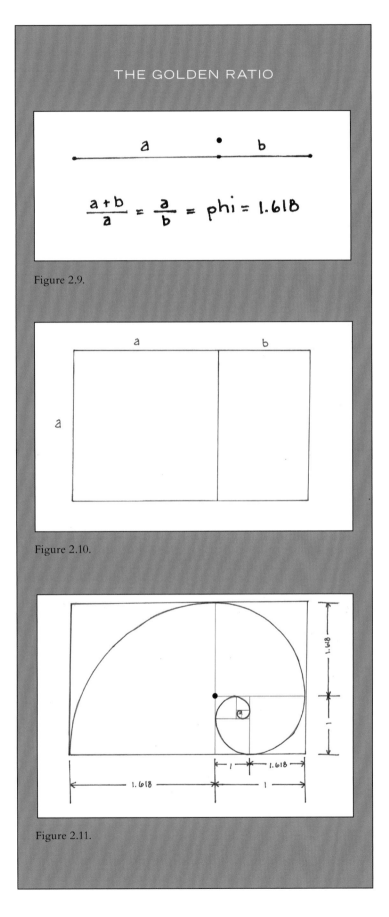

**THE GOLDEN RATIO**

$$\frac{a + b}{a} = \frac{a}{b} = phi = 1.618$$

Figure 2.9.

Figure 2.10.

Figure 2.11.

Figures 2.2 to 2.7, because the examples refer to values only). For good measure, if you're painting a lone barn, place a house next to the barn and a tool shed next to the house even though they don't exist. This isn't a commandment, Crow's Nest (Figure 2.8, page 19) has the barest hint of a building behind it. It was painted using the value plan in Figure 2.2. I thought it was a failure because of all the smudges, but my teacher assured me that the smudges added to rather than detracted from the painting.

No. 3: The land, sky, clouds, and mountains in your sketch must contain at least three values (light, medium and dark), but make sure the darks of the sky are lighter than the darks of buildings, and the dark, medium and light of mountains are different at different distances from the viewer.

Figure 2.1, is an early study painted from imagination after I did the mandatory thumbnail sketch. It stands on its own, but a similar scene could have had more trees, and also clouds and faded hills in the distance painted with respect for the Rule of Threes. Notice that the value plan is the same as Figure 2.4, which is a plan that, like Figure 2.5, is not commonly used.

On the thumbnail sketch, it's also important to establish the horizon line (the line of the apparent meeting of the sky with the earth or sea). Where does the valley end? Where do the mountains begin? Is there room enough for sky? Is there room enough for foreground structures?

The linear perspective of a road or river slanting its way into a landscape, with its parallel sides converging to a faraway vanishing

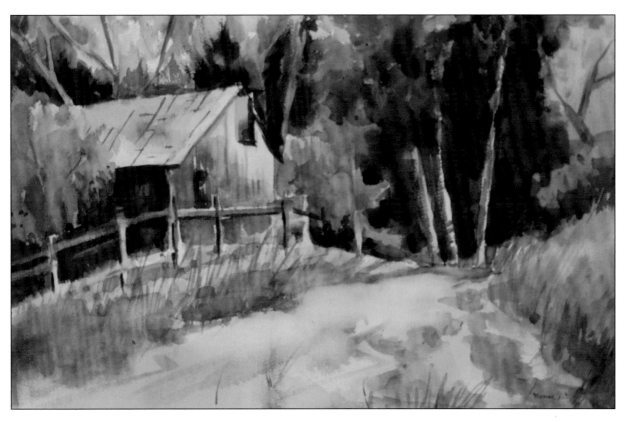

Figure 2.12. *My Neighbor's Barn.*

point, suggests three-dimensionality. A fence can do the same thing (Figure 2.1). That's the power of the oblique. That's why twisting a barn or a boathouse on the picture plane so that it appears as a cube rather than a square makes a difference in suggesting the third dimension.

Most master works have more gray in them than people think. Your landscape should contain either a medium-sized light area and small dark area surrounded by a large gray or a medium dark area and a small light area surrounded by a large gray.

## Handling Watercolor

On a large pad of paper mounted on an easel next to my work area is a list of suggestions written in black ink.

| PAINTING SUGGESTIONS |
| --- |
| 1. Use the biggest brush |
| 2. Control amount of water in brush |
| 3. Keep rag in other hand |
| 4. Feather dust |
| 5. No hard edges |
| 6. Three or more values (shades of light and dark |

## Trust the Ancients

The Golden Ratio, a concept of plane geometry as old as the Persian mathematicians, will help you to ensure that your placement of pieces is pleasing. In geometry there is a point to divide a line so that the ratio of the large part to the small is the same as the ratio of the whole line to the large part. This point, the Golden Ratio, is 1.618 to 1 (Figure 2.9).

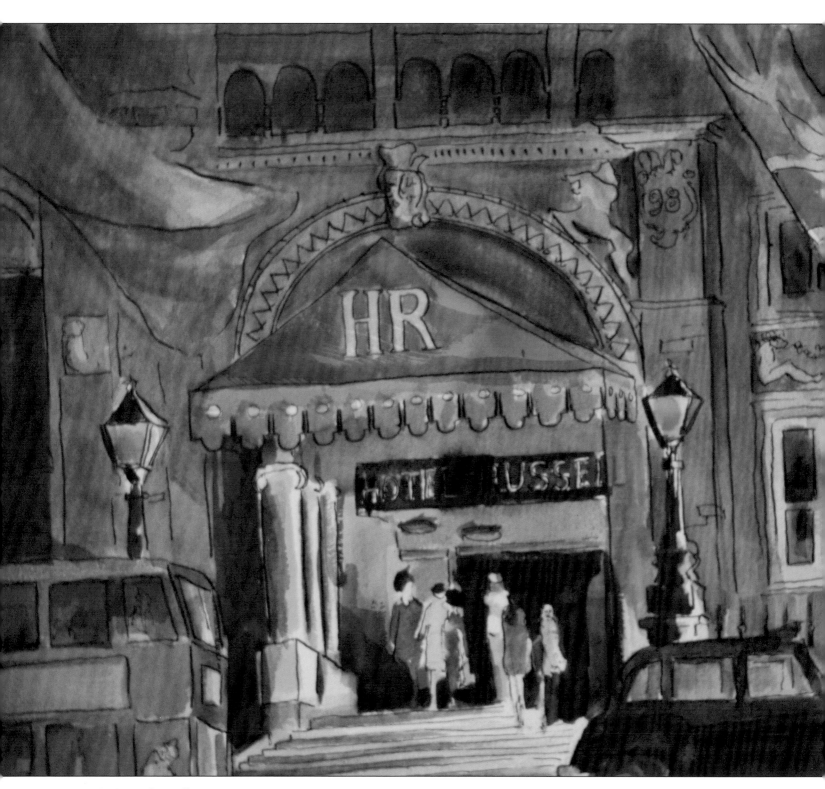

Figure 2.13. *Hotel Russell.*

If a rectangle has a ratio of 1 to 1.618, we have a golden rectangle (Figure 2.10). If the rectangle is subdivided into a square and a rectangle and the operation is repeated several times, we get this (Figure 2.11). Within the geometric subdivisions thus formed, I've drawn the outline of a seashell.

I've found that the best place to put the dominant object of a painting is where I've placed the black dot on Figure 2.11, which is about $^4/_7$ths of the way across and $^4/_7$ths of the way from top to bottom whether it's on the right or left or high or low. On Michelangelo's fresco, The Creation of Adam on the ceiling of the Sistine Chapel, the fingers of God and Adam touch at the Golden Ratio. The dominant figure in many masterworks is at the Golden Ratio.

Our brains appear to be hard-wired to favor works of art that maintain the Golden Ratio of small pieces to large and large pieces to the whole. The pieces, whether they're structures, trees, rocks, mountains or empty spaces, shouldn't be boring: They should have different lengths and widths and heights that are suggested by phi, the Greek letter that symbolizes the 1 to 1.618 Golden Ratio.

Most of my watercolors are done from imagination in my untidy right-brained studio, but there is an island of order and dentist-like neatness amid the chaos. I select my best thumbnail sketch, usually the first. It may include trees or houses that may not make it into the final painting. It is my blueprint. I don't build a house or a painting without one, and I hope you don't either.

It's important to figure out ahead of time the location of light, dark and mid values. Brushwork must be decisive and clean. You have to force yourself not to make lines or brushstrokes until you can visualize them. Visualizing and doing the same study over and over can lead to a painting worthy of signing. Most students jump right in and try to make complicated pictures rather than studies. Artistically speaking, the worst thing in the world is picture-making. My advice is to solve basic problems before tackling complicated ones.

With your value plan before you, start with your lightest colors. Holding a rag in one hand and painting with the other, lay on a wash and gradate it, "feather dusting" (applying the paint as lightly as possible) to avoid leaving a hard edge. If more of the same color is needed, wipe

the brush dry before putting it back into the paint pot. If a different color is needed, rinse the brush with water and wipe it dry before dipping it into the paint again.

When I began painting in watercolor, I familiarized myself with transparent non-staining colors that could be washed away, opaque colors that left interesting grainy sediments on the hills and valleys of the rough paper, and staining colors that stayed forever.

I advise you to use a light touch and don't paw at your marks. Place them and leave them. Sometimes you will produce washes with blooms or hard lines that are anything but graded. Blooms happen when the paper is too wet from a previous soaking, and the paint billows forth like a flower opening up. Hard lines happen when the paper is not wet enough. When a bloom or a hard line occurs, the result is often disastrous, but once in a while the result is stunning, and that is referred to as a happy accident. You have to know when to add color to a moist surface. Like everything else in art, it comes with practice.

Capturing a scene's essence can be elusive. Ask yourself questions and be able to answer them. What is it about a particular setting that grabs you? Is it the mystery and drama of a low-key scene dominated by darks as in *My Neighbor's Barn* (Figure 2.12, page 21)? When is the best time to paint the scene? Morning? Evening? Noon? On a foggy day? From what vantage point would it be best to paint it? I painted this quick watercolor sketch of the Hotel Russell in London from a park across the street (Figure 2.13). It was painted in the morning, but when I returned to Napa weeks later, I changed it to a nighttime scene.

What about color and color harmony? The primary colors — red, yellow and blue — are equi-distant from each other on a color-wheel. Three evenly spaced colors between yellow and red, for example, are yellow-red, which has more yellow in it than red, orange, which has equal amounts of yellow and red, and red-yellow, which has more red in it than yellow. Think about the spacing between the other two primaries in the same way. The dominant color of an effective painting will work well with two closely related colors from the complementary side of the wheel.

I critique students' paintings respectfully, careful not to damage their creative spirits. Whether I like a painting or not doesn't matter. What matters is its adherence to the Principles of Art, which will be discussed in the next chapter. When you visit local galleries, you'll appreciate the lightness, the glow, and the ethereal quality you can get with watercolor, and you'll undoubtedly see work that is cleanly done, triple-matted and exquisitely framed. But is it fine art? Is there too much emphasis on technique and too little on composition? Are the watercolors cloyingly sweet, picturesque subjects with no mood, no simplicity, no people to give the paintings a comfortable sense of dimension? Is too much emphasis placed on reflected light, vivid color and boring pattern, and is there too much contrast of warm and cool for their own sake? Is there too much icing and no cake? The best technique in the world can't save a poor composition. At best, one winds up with a brilliant illustration or a camera-like picture, but a good composition, an arrangement of visual elements based on the Principles of Art, will save or hold together a painting that lacks technical skill. So, with technique alone, one gets an illustration, and with composition, one gets a painting. With both, one gets fine art. The artist wants the viewer to be enthralled with his art, not with the frame.

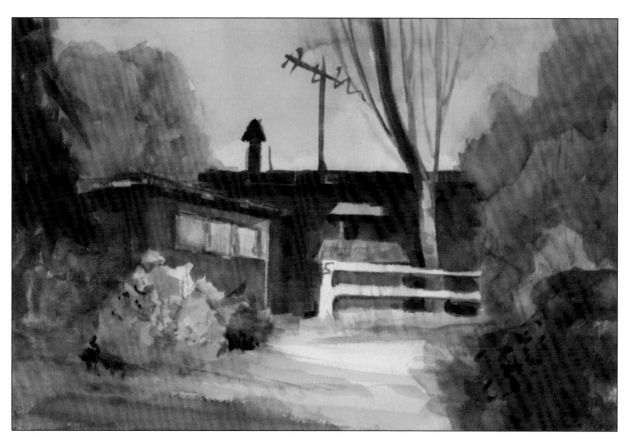

Figure 2.14. *Bill's Shanty.*

| THE ARTISTIC SPECTRUM |
| --- |
| 1. Photo-realism (relies almost totally on the object) |
| 2. Illustration |
| 3. Expressionism |
| 4. Abstraction |
| 5. Non-Objectivism (relies almost entirely on formal relationship) |

My art lies in the middle of the artistic spectrum. I want it to exhibit emotion, poetry, character and symbolism. A little abstraction and distortion is okay too. Although I have nothing against non-objectivism, which relies almost totally on shape, color, space and design, I like to see it only in the under-painting. When you paint, pay attention to where you are on the list. If, for example, your man-made structure begins to look too much like a photograph, soften some lines or fuzz something out.

Here's the driveway leading to my teacher's studio (Figure 2.14). No pretty picture here, only feeling. Technique mattered less than my clarity of purpose, which was to portray his house as moody and brooding as he often was. The rickety wooden rear deck, cantilevered over a slough that empties into the Napa River, is often bathed in sunlight. It's where I learned to paint in watercolor.

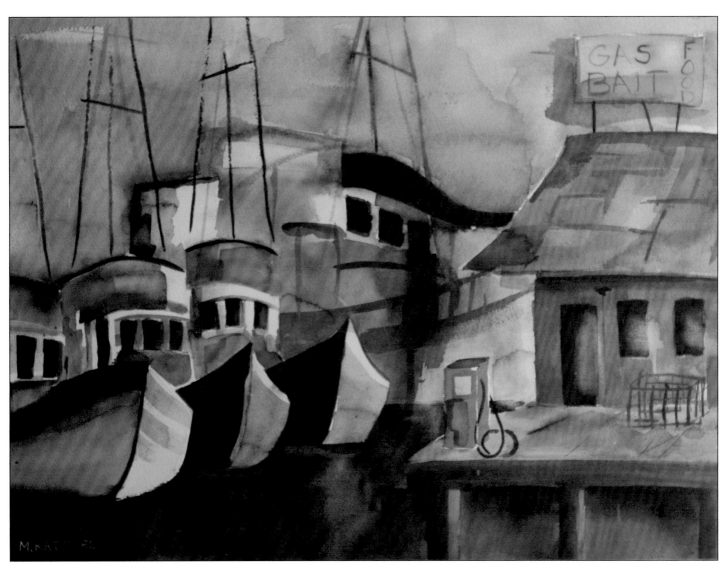

Figure 3.1. *Fishing Boats*.

# The Language of Art

"There are two kinds of truth: the truth that lights the way and the truth that warms the heart. The first of these is science, and the second is art."

— *Raymond Chandler (1888 - 1959)*

Science and art were my favorite subjects in grade school. When I grew up, I chose a profession that allowed me to practice both at the same time. I became a dentist. Fillings, crowns, bridges and dentures have to satisfy a structured scientific model, but they also have to be pleasing to the eye. Painting, like dentistry, must be performed in an orderly, structured manner and be pleasing to the eye. And wonderful things happen when logical procedures — developed and refined over the years — are followed with reverence.

Good paintings are not mishmashes of colored shapes. They are well-planned compositions.

On the first day of my formal art training, the instructor handed me a list of the Principles and Elements of Composition, the language of art. The great masters have developed and used this guide for centuries. The elements are things you create with a brush in order to master a principle.

| PRINCIPLES OF COMPOSITION | ELEMENTS OF COMPOSITION |
|---|---|
| 1. Balance | 1. Line |
| 2. Dominance | 2. Value |
| 3. Repetition | 3. Color |
| 4. Gradation | 4. Texture |
| 5. Harmony | 5. Shape |
| 6. Alternation | 6. Size |
| 7. Contrast | 7. Direction |
| 8. Unity | |

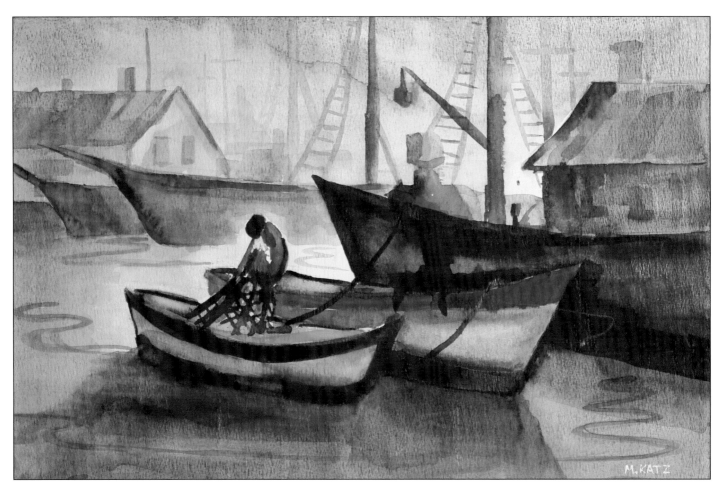

*Figure 3.2*. Fisherman Tending His Net.

Principles give structure to art, and the highest principle is unity, which is achieved by mastery of all the other principles. Even though the principles aren't rules that must be obeyed, don't take them lightly. Ignore them at your own risk!

### The Elements of Composition

To depict the elements in myriad ways, in watercolor, all you need is a brush, water, paint, paper and a bit of imagination. Let's look at how I've used the seven elements of composition in *Fisherman Tending His Net* (Figure 3.2), a primitive early watercolor of mine.

LINE is the basic element of art. My lines are light and dark, thick and thin, wide and narrow, vertical, horizontal, diagonal, curved and zig-zagged.

Besides adding interest, their main function here is to guide the eye.

VALUE ranges from white to black. The extremes of value clash at the focal point, where the fisherman is tending his net.

COLOR repeated throughout the painting is a cool red, which harmonizes all of its parts.

TEXTURE is smooth and rough. There could have been more rough areas. It's important to convey visual texture, how a surface might feel if it were touched.

SHAPE is repeated and harmonized by boats, buildings, masts, rigging and background. Overlapped shapes create depth. Positive shapes create negative shapes.

SIZE is an indicator of visual weight. The intense color of the two small fishing boats and the fisherman are not quite enough to balance the weight of the dark boat.

DIRECTION of the viewer's gaze is influenced by arrow-shaped prows of boats and angles of roofs, rigging and shadows. It's up to the artist to neutralize arrows that take the viewer out of the picture plane with arrows that bring the viewer back in.

## The Principles of Composition

On the above list, they are listed in ascending order of difficulty, with balance the easiest to attain and unity the most difficult.

BALANCE creates a sense of stability that makes viewers feel comfortable. I prefer asymmetrical balance, where one side of a painting is different from the other, but the objects on each side have an equal distribution of weight, which can be a function of color, size, value or placement. An object near the edge of a painting has more weight than an identical one at the middle. An isolated object has more weight (visual attraction) than one placed with other objects. Imagine your painting resting on a fulcrum. Your task is to add or remove weight from one side or the other to keep the picture from tipping.

DOMINANCE is one of the first things to look for. A painting must have a subject that catches your eye and holds it. It can also be a color, shape or object that grabs your attention, like a black sheep in a herd of white ones. All other features are subordinate to it. If there is no dominance, your eyes wander here and there, and you get lost. Will I get lost when I look at your painting?

REPETITION of one or more elements, especially lines and shapes, suggest movement and rhythm,

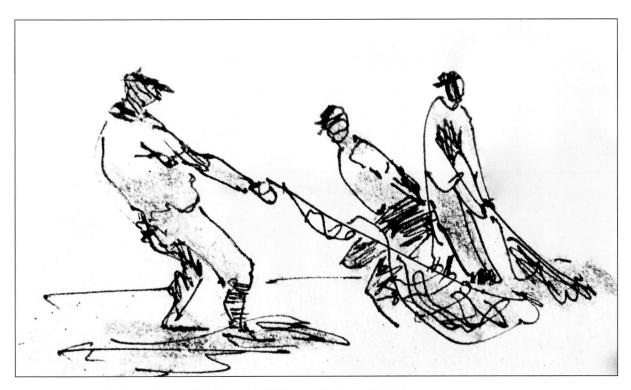

Figure 3.4. A skectch by my teacher, Bill King, titled *Fisherman Hauling in Their Nets.*

Figure 3.3. *Fisherman Walking on the Beach.*

which makes a drawing or painting exciting. An example is my teacher, Bill's, drawing of fishermen hauling in their nets (Figure 3.4). I can feel the weight of the nets. Are your drawings exciting?

GRADATION keeps the eye moving from one color or value to another in a regular progression of steps. The sky in your painting might be dark blue on top and gradate to a light blue as it reaches the horizon. Your mountains may become lighter and bluer as they fade into the distance. By use of repetition, alternation and gradation, movement happens, and it requires a bit of trial and error in the handling of the elements for the artist to speed up or slow down that movement. (More about this later.) Sneaking up on a problem works for me, and it will work for you, too.

HARMONY is achieved when all parts of a painting relate to and complement each other. One way to achieve this is to repeat similarities throughout the painting. Look at any Whistler work and study his handling of tone and color. Whistler was the master of harmony.

ALTERNATION is the repetition of movement suggested by one or more elements. Lines go from straight to curved, values from light to dark, color from warm to cool, texture from smooth to rough, shape from round to angular, size from large to small and direction from horizontal to diagonal to vertical. All these changes keep our eyes moving.

CONTRAST or conflict is the opposition of forces that give rise to the dramatic action in a book

or a play. Your painting also needs conflicting parts, such as waves crashing on rocks, bows of sailboats pointing this way and that in a harbor, or merely the opposition of black and white, angles and curves, rough and smooth texture, any type of discord to make what you see enticing. In the museum, as in the theater, we want the viewer to stay awake.

UNITY is what a painting has when all of its parts seem to belong together, and nothing is out of place. A good painting contains planned distractions and necessary diversity, but they fit comfortably into the whole. The achievement of unity is easier said than done.

There's no clear line between some of these principles. Harmony and unity become indistinguishable at some point, as do repetition and alternation, but the principles work together despite defying strict definition.

A painting is a planned production. If a thousand monkeys were given keyboards, eventually one might type daddy loves mommy, and I suppose one of a thousand unschooled painters might occasionally produce a good work of art, but the odds are against it. It's difficult enough to produce fine art even when the principles are obeyed. Think about the elements and principles before you touch brush to paper. Once they become ingrained, you won't have to think about them.

In *Fisherman Tending His Net* (Figure 3.2) the values were handled with a lack of finesse. I spent so much time and effort scrubbing out darks, abrading the paper surface, leaving stains and making mud that all I saw was a harmony of blemishes. This watercolor has unity all right; it's uniformly bad.

My painter friends didn't share my opinion. Jon pointed out that the fisherman is dissimilar to any other object in the painting. He said the fisherman is an anomaly, which, because of his rounded shape, location and my use of chiaroscuro, dominates the scene and provides balancing weight.

Jay said if the boats and buildings were painted separately on different canvasses, they would be boring, but here they complement each other. There's a gestalt, an organized whole that cannot be described merely as a sum of its parts.

Bill, the teacher, said the boats and buildings are in the right places, and the scene is composed reasonably well; it's my brush-handling that needs improvement. He advised me to apply the paint and leave it instead of going back into a painted passage and making mud.

The next marine scene I painted, *Fishing Boats* (Figure 3.1), would have been more interesting if it had had a fisherman or two standing on the dock. Here they are, in a later painting, *Fishermen Walking on the Beach* (Figure 3.3).

When you think your painting is done, put it aside for a day or two, then come back to it. You'll see things you hadn't seen before. Critique it, keeping in mind the Principles of Art. You may decide to repaint a few areas before you seek criticism from your artist friends.

Figure 4.1.

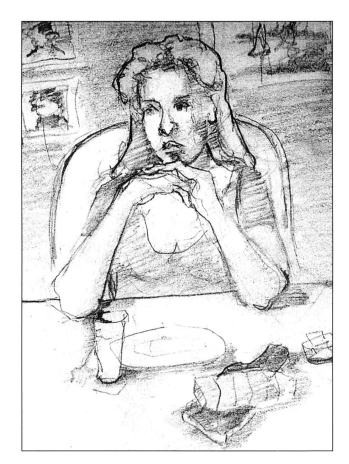

Figure 4.2.

Figure 4.3.

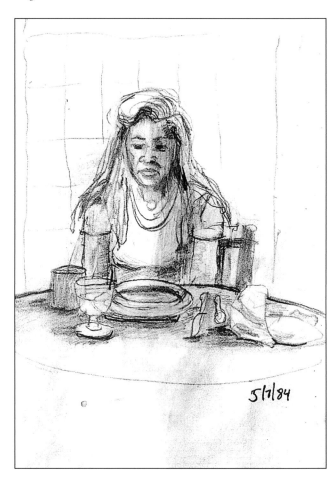

Figure 4.4.

# Capturing Character

"Beauty is something wonderful and strange that the artist fashions out of the chaos of the world in the torment of his soul."

— *W. Somerset Maugham (1874–1965)*

A portrait that is meticulously copied from a photograph seldom captures the subject's true character. When I paint from a photograph I lie a bit, tweak the smile, darken the eye sockets, remove a mole, muss the hair, change whatever I see fit to change. The portrait becomes a lie, but it helps me to convey the character of the person.

At one stage in my development I temporarily gave up self-portraits and portraits of family and friends. When I tried to capture my own likeness from a mirror, for example, I spent a lot of time and energy on trying to achieve perfection, and my unconscious didn't have a chance to do its thing. As a result, my work was stiff. My problem was to get the understanding into my brush hand.

Chinese masters advise their students to think long and carefully, then paint like madmen so that their unconscious understanding goes into the brush spontaneously. In drawing or painting one has to act quickly, decisively, intuitively.

My approach is to draw from memory every day and draw fast and furiously. I don't worry about an exact likeness or any likeness at all. If you do this over and over, eventually you'll be able to capture the likenesses of loved ones, and they won't be stiff, because the fundamentals will flow from your hand to the brush without conscious effort. And you'll feel like an artist.

•   •   •

My late wife, Aileen, would read a book a night, and a year later she could still tell you all about it. I often drew her as she was reading at the kitchen table, stopping occasionally for a bite of toast or sip of tea. I made sure to throw away my eraser so I wouldn't be tempted to correct a line. Figure 4.1 was inspired by Rembrandt. At restaurants, I

Figure 4.5. *Aileen in watercolor.*

would fill paper placemats with pencil portraits of Aileen. I even drew her in airport waiting rooms, and she invariably would look as though she was deep in thought (Figures 4.2 to 4.4).

"Do you have fun when you paint?" she once asked me.

"It's not exactly fun," I answered. "It makes me as tired as digging ditches, but it's something I'm compelled to do. And it gives me pleasure and a sense of relief when it's finally finished."

When I painted her in oil, I prefered to do a watercolor study first. I can finish a watercolor in an hour compared to thirty-six hours or more for oils. But watercolors are hard to correct. I remind myself to think long and carefully before I pick up the brush. Of course, the thumbnail sketch is part of the thinking process.

I'd paint Aileen in watercolor as she sat in a chair with a book on her lap and a sweet look on her face. To capture her softness and serenity, I used diffused lighting, understated shadows and avoided sharp edges. But it was difficult to paint her, because she'd keep reading her book, and I'd keep telling her to look up. When I was done, she and my picture of her looked more sad than sweet (Figure 4.5).

Now, at this point, let's consider the pros and cons of watercolors and oils. Watercolor is the least expensive painting medium if you buy quality paper and paint. Using cheap paper and student-grade paint will lead to frustration and the trash can. Cheap paint neither covers nor handles as well. Don't wait until you get better at painting to use the best supplies. Use them now! Watercolor is challenging. Mistakes are difficult to correct. It takes much practice to do a painting right the first time, and even if it is right, a drop of water in the wrong place can ruin a vibrant passage. But on the plus side, large areas are easier to cover, brushes can be cleaned in seconds in water, and there is no odor so watercolors can be used in enclosed spaces. An even bigger plus is that watercolors travel easily, because they dry quickly in the sun or with a hair dryer. On trips, I carry a pack of D'Arches 9 x 12-inch paper and a portable pallette that holds solid-color blocks of paint and a brush. That's all I used to paint some of the pictures in this book.

Oils are stinky, messy, slow drying, can stain fingers and clothing and can irritate the skin. The fumes are toxic. Brushes take a long time to clean, and if they're not cleaned promptly, they're ruined. Oily rags can cause spontaneous combustion. A freshly-painted canvas doesn't travel well. On the plus side, because oil dries slowly, paintings can be tweaked, softened, blended, scraped out and re-painted without ruining them. Dry, thickly-painted areas may have to be sanded down before re-painting.

Stretched and mounted canvases in standard sizes are available in cotton, linen and synthetic materials. For the painting of Daphne in the next chapter (Figure 5.1) I stretched an odd-sized linen canvas over home-made wooden stretcher boards, tacked it down with brass tacks, sized it with rabbitskin glue, gessoed it and primed it. I've also painted on wood and on canvas that was glued onto wood, but I prefer the feel of stretched canvas.

Here's what went through my mind while painting Aileen's portrait on an 8 x 10-inch tinted linen canvas: No preliminary drawing needed. I knew her face by heart. For the underpainting, I dipped a small round brush into thinned burnt umber paint and rapidly blocked in her face, paying attention to approximately where the eyes, lips and chin would go. It was tempting to draw her sparkling eyes right away, but I didn't yet know

Figure 4.6. *Aileen in oil.*

exactly where they'd be. Patience. I had to force myself not to think of noses, lips or ears. Better to think abstractly, to paint the small, medium and large masses of light and dark, establish the planes of the head. The different degrees of light, medium and dark needed to be just right, and the shapes of the planes, accurate.

When students render specific faces, they spend so much energy on achieving a likeness that they often drain away the painting's vitality and magic. I didn't try too hard for a precise copy of Aileen's face, but although no features were discernable yet, there was no doubt that it was Aileen on my canvas. The painting already had three-dimensionality and weight. The eye sockets and neck were pushed back, because they were purposely left in shadow. The nose and lips came forward before they were even defined. When they finally were defined and I was satisfied with the monochromatic result, I let the under-painting dry, turning it to the wall so I wouldn't be tempted to make changes.

In a week the painting was reasonably dry. I studied it without brushes in hand. Putting my brush down was like taking off my artist's hat and becoming a critic.

What could I say about my progress? Proportions were correct, lights and darks were in the right places. I'd concentrated on painting form with as wide a brush as possible rather than filling in outlines. Aileen's portrait had been intensified gradually so that at any stopping point it looked like a finished painting with nothing more to add to the under-painting nor anything to take away. Leonardo da Vinci said, "A poet knows he has achieved perfection not when there is nothing more to add, but when there is nothing more to take away." That statement applies to painting also.

It was time for color, so I referred to my "Order of Perception #1" list. I'd done my share of portraits that didn't follow the correct order, and it took much longer to fix them than if I had followed instructions.

| ORDER OF PERCEPTION #1 |
|---|
| 1. Eyes. Viewer's attention should go to eyes first. |
| 2. Nose. Accentuate shadow under nose. The bridge should be unseen. |
| 3. Mouth. Corners should be dissimilar to create back and forth tension. |
| 4. Chin. Paint shadow under chin. |
| 5. Face. Should come to viewer's attention only after above items. |

My "Order of Perception # 2" list is even harder to correct. Sometimes I have to backtrack to the monochromatic stage or even start over. It's often easier to re-do a painting from scratch than to try to salvage one.

| ORDER OF PERCEPTION #2 |
|---|
| 1. Light (should come to viewer's attention first.) |
| 2. Color (should not pull attention away from light.) |
| 3. Middle tones. |
| 4. Dark tones. |

I maintain this hierarchy of perception to create a painting that's easy to look at, but mistakes can sneak up. Usually viewers look at the eyes first. If attention goes to the face's color first, there will be a burnt look, so I'm careful when I add a glaze of delicate red or yellow, depending on the subject's complexion, to unify the under-painting. I've altered contrasts of tone (light and dark) with color, and minor plane changes with warm and cool versions of the same color. Oils are easier than

Figure 4.7. *Aileen in oil, front view.*

watercolors. Mistakes can be wiped out to expose the dry, unsullied under-painting, but these days I make fewer mistakes, such as failing to make one eye dominant. Lips are difficult. An almost imperceptible change in line can alter an expression dramatically. Aileen's lips were painted and scrubbed out five times before I was happy with them.

Her completed portrait has a wistful, dreamy look, as do most of my paintings of women (Figure 4.6, page 36). One reason is my use of cool, somber colors. Another is my use of frown lines, like a happy face turned upside down. Her hair, forehead, eyebrows, upper eyelids and upper lip curve sadly downward and are accentuated by hard lines and more intense color. Trees, too, can be made happy if their uplifting branches are accentuated, or sad if their down-turned foliage is accentuated, as it is with weeping willows. Add a few hooded figures or people with umbrellas to create a picture that's downright depressing. Figure 4.7 is a feistier interpretation of my quick-witted Irish wife. The upturn of her chin and lower lip neutralize the downswept features.

### An Epiphany

One day, on the drive to the M. H. de Young Memorial Museum in San Francisco, I mentioned to Aileen that I was still trying to escape from the tight, constrained, methodical me. "I want to be loose and free," I said, "but it's hard for a dentist to be anything but exacting. Crowns have to fit flawlessly, preps have to be cut precisely, teeth have to come together perfectly."

"You told me that dentures are different," she replied. "Teeth must be moved, turned this way and that, so the smile looks natural."

"It's just an illusion that masks a perfect underlying occlusion."

"Well there you have it, and poetically at that.

You've solved your own problem. Abide by the Principles of Composition, then tweak your paintings as you do your dentures, giving the viewer the illusion that the work was not done by Monroe the machine, but by a living, breathing artist."

I pulled her over to me and gave her a big hug for giving me that revelation in which I suddenly saw how to solve my dentist/artist dilemma.

At the museum, we immediately went to see Rembrandt's *Joris de Caullery*. It was reassuring to visit an old friend. The great master, as usual, communicated with me through his painting: "See how I handled the light on the collar and the luminosity of the metalwork. Joris looks as if he can step right out of the canvas and shake your hand, but why would he want to shake a timid hand that isn't used to best advantage? Where is the drama in your work, the passion, the depth of human soul? When are you going to be a free spirit, break yourself loose and follow your star?

"I know you're here because no picture in a book can take the place of seeing the real thing. Look at my handling of chiaroscuro. Do you think I had a value plan? Why does my painting look alive?"

It's a great feeling to be so enamored of an artist that you can imagine him speaking to you — even if he does give you hell on occasion.

With Aileen by my side, I studied a Rubens, then a Hals and told her that the planning that goes into a painting is the same regardless of who the master is. In another room were still-lifes that were a tour de force of slick brushwork: gleaming wine glasses, ornate tableware, birds, rabbits, deer, fruit, fish that I could almost smell and bread that made my mouth water.

I used to wish I could paint like that, but not any more. I'd be wasting my time. Why spend

weeks or months doing what a camera can do in a second? The small Chardin painting by the door, on loan from the Louvre, is what I should have been studying. Chardin, with his dramatic use of light and shadow, is the Rembrandt of still lifes. He wasn't obsessed with painting the perfect cluster of grapes or a bouquet of perfect flowers. He was concerned with balance, composition and harmony. His paintings are unified by masterful reflections of colors that act as mirrors to other colors. He wasn't interested in minute detail but in the distribution of light and shade and textured brushwork. He was a painter's painter. That day at the museum, I wound up no longer liking some of the still lifes I've admired for years and appreciating some that I hadn't previously cared for.

At home, I took a break from portraiture to study Chardin, copying a few of his still lifes painstakingly, paying attention to the slightest nuances, his use of warm and cool, and his relationship of foreground to background. Chardin painted simple household objects in a limited range of

Figure 4.8. *Red Onions.*

colors. He transformed ordinary things like wine glasses, a jar, a bowl of fruit and a loaf of bread into sublime objects.

I applied a mixture of lead white and reddish brown to my canvas, added the darks, half-tones and lights and spent three weeks struggling with the subtle harmonies of Chardin's *The Jar of Olives*, which was considerably more detailed than I had thought. I was finicky, insisting on a perfect reproduction of the Chardin right down to the reflections in the glassware and on the tip of the knife handle. It was the most technically demanding piece I had ever painted. Whenever I thought it was finished, I found some subtlety that could be improved upon. I worked on highlights, rhythm, and balance until I pronounced the work done. Nothing could be added or taken away without spoiling the picture. Chardin achieved harmony and unity. Studying his work, I gained deep respect for *The Rembrandt of Still Lifes*. *Red Onions* (Figure 4.8) is a still life of my own design.

When you carry over to portraiture what you learn from Chardin, you'll be a giant step ahead in your quest for feeling and emotion, and you'll be able to paint better portraits. See Figures 4.9 to 4.15 for my pastels and oils of pensive women done after I had studied Chardin.

My advice is to paint a series of portraits in oil, paying attention to the orders of perception. Do your paintings emanate from the canvases gradually the way a Polaroid did? What would Rembrandt or Chardin have to say about your tonalities and your use of warm and cool in the foregrounds and backgrounds? Have you achieved harmony and unity?

Figure 4.9. *Pastel of Pensive Woman.*

Figure 4.10.

Figure 4.11.

Figure 4.12.

Figure 4.13. *Woman in Brown Dress*

Figure 4.14.

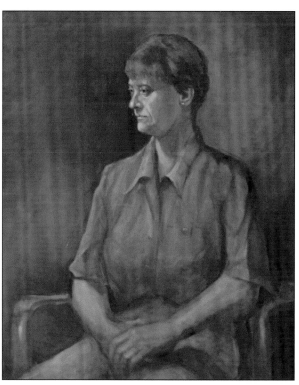

Figure 4.15.

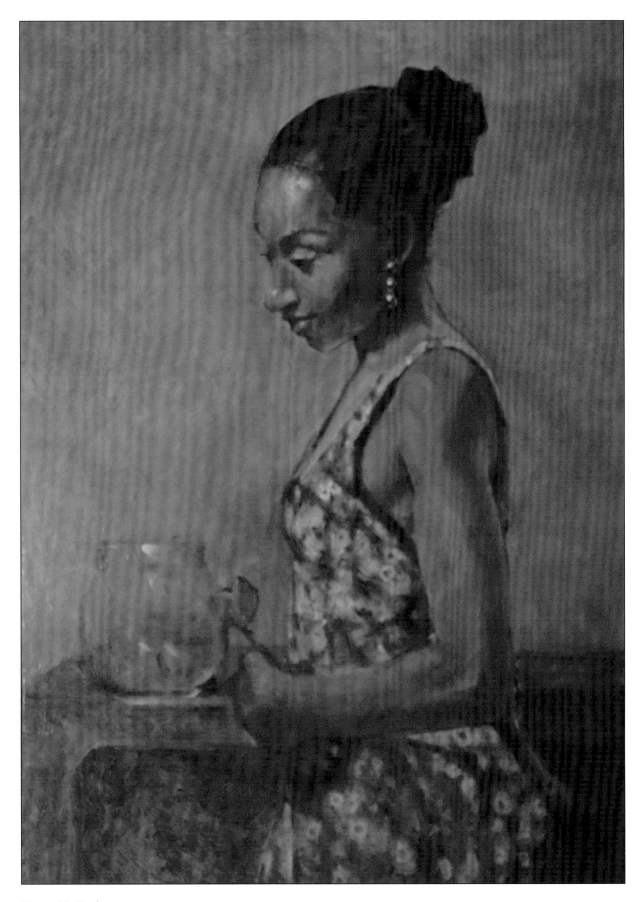

Figure 5.1. *Daphne*.

## Torture and Joy

"Ask your work what it needs, not what you need. Then set aside your fears and listen, the way a good parent listens to a child."

— *David Bayles, photographer who studied with Ansel Adams (b. 1952)*

When I'm inspired to capture on canvas a painterly face, a dynamic pose, or the light and shadows slanting across a country scene, I feel a sense of purpose in this world. Wonderful! I feel challenged. I feel that I'm doing what I'm supposed to be doing. And I think my pal Rembrandt would be pleased for me too. Then the torture inevitably begins.

Let me share with you a particularly poignant case in point, the story of a beautiful woman named Daphne.

One day I was attending a dental course, and across the aisle from me was a painter's dream, a young woman with a very distinctive look and allure. Immediately I wanted to recruit her as a model. So I found some lame excuse to approach her. Her name was Daphne, she told me, and by profession she was a dental assistant. Now I was really smitten. "You remind me of Nefertiti," I told her. She gave me a quizzical look, so I went all in: "Nefertiti means 'the beautiful one has come'" Well, that got her attention! And soon she agreed to sit for a portrait.

As soon as we set up a painting session, I decided to capture her Nefertiti-like dignity of bearing with a standing ¾-length side-view portrait. I would use a 16 x 24-inch finely woven Claessens linen canvas from Belgium which I cut and tacked onto stretcher bars. Before Daphne arrived, I uncapped tubes of burnt sienna, ultramarine blue, and lead white, squeezed them onto a glass palette and swirled them together in turpentine with a large round bristle brush. This gave me a neutral gray to apply to the pre-primed white canvas to tone it, because it's unpleasant to work on a glaring white canvas.

The upper left corner of the canvas would be cool, so I'd add a hint of blue, and as I painted my way to the upper right corner, I'd include a hint

of burnt sienna for warmth. I walked to the wall eight feet away to look at the canvas with the light shining on it as it would on the model when she's posing, and I'd go back to adjust the warms and cools. I decided to scrub out the burnt sienna and re-apply it in a blotchy manner, without blending it thoroughly, so the background wouldn't be boring. In one hour, this thin first coat would be dry.

Why was I using Belgian linen and expensive Old Holland paints? Why was I so psyched up? Daphne moved me. I was in love with Daphne! So was Aileen, my wife. So were my artist friends.

Daphne walked into my studio carrying an armload of dresses, but the sleeveless gray one with small white flowers that she was wearing was perfect. She stepped onto the six-inch-high modeling stand. The single low-wattage floodlight shone down at a 45-degree angle. She tilted her head so the light wouldn't shine in her eyes. But something wasn't right; her arms couldn't be left dangling. I handed her a book to hold in both hands, which gave her something to do. Then, settled in, she seemed to be thinking about a chapter she'd just read.

I decided to attempt the painting without a preliminary charcoal sketch. I dipped a small round brush into a puddle of thinned burnt umber and paused, clearing my mind like a concert pianist does before beginning to play. With one quick slash of paint I captured the position of Daphne's backbone and the slight twist of her figure. I exaggerated the pose. If I didn't, her figure would straighten itself out as the brush-drawing progressed and look stiff. As I roughed in her torso, the oval of her head and her pelvis, I connected them with lines to other parts of the body as well as to wrinkles in the drapery behind her. Although Daphne was new to modeling, she held the standing position like a pro.

Lest you think that going straight to paint without a preliminary sketch is foolhardy, let me add that I've done years of homework to get to the point where I'm able to capture the backbone's position and the slight twist of the figure with one slash of paint. These days, I do things automatically without having to refer to lists that are part of me now. As I draw with a thin round brush, I imagine myself in Daphne's pose, sharing horizontal and vertical axes, weight distribution and balance. My lines and planes are her lines and planes. I concentrate on the whole form and the concept of form over form. Working with a skeleton and with Grant's *Atlas of Anatomy* has helped me visualize insertion points of Daphne's muscles.

After I had tentatively established the big form, I roughed in her arms, hands and book and stood back to see if my marks were in the right place. They were. I had lined up one feature with another — whether a knuckle, a freckle or a shadow — allowing me to place lines and points and rectangles where they belonged.

Aileen popped in with coffee and pastries and scolded me about forgetting to give models a break every 15 minutes.

"You're drawing rectangles, aren't you?" she said.

"Guilty as charged."

"Why those particular ones?"

"Daphne's upper arm is long and dominates the drawing, so I de-emphasized it by leading the eye away. I did this by crossing the arm with rectangles that join the arm to the background. Velasquez did the same thing with his reclining *Venus at Her Mirror*. He crossed the leg with barely perceptible lines and shadows that neutralized its linearity. Sometimes all it takes to cross a leg or

arm and neutralize it is a change in temperature."

Enough drawing. It was time to under-paint the figure monochromatically in a wide range of grays made from the burnt sienna, ultramarine blue and lead white that I had used earlier to tint the canvas. Added to that mixture was a hint of red for warmth. I use the list below page as a reminder of how to suggest depth:

| TO MAKE THINGS ADVANCE | TO MAKE THINGS RECEDE |
|---|---|
| 1. Lighter in tone advances. | 1. Darker in tone recedes. |
| 2. Rougher in texture advances. | 2. Smoother in texture recedes. |
| 3. Warmer in temperature advances. | 3. Cooler in temperature receeds. |
| 4. Brighter in intensity advances. | 4. Duller in intensity recedes. |
| 5. Opaque pigment advances. | 5. Transparent pigment recedes |

The light areas of Daphne's forehead, cheeks, nose, arms, hands and chest were made warmer, lighter, brighter and thicker so they'd stand out. The darker, cooler areas of her figure were painted thinly and transparently so they'd recede. The background and the figure were united by the darker, cooler color, and I made sure to preserve the rectangles, bony landmarks and paths for the viewer's eye to follow. What's underneath needed to be evident and stay evident throughout the painting, because that's what gave it its inner life. But I'm talking subtlety here.

By doing the under-painting in all the shades of gray I saw on the model, without getting hung up on any one spot, the image appeared like that developing Polaroid film and was beginning to resemble Daphne even though her eyes, lips and nose weren't yet fully rendered. (I know I use the Polaroid analogy a lot, but painting this way helps to avoid disharmony.) Daphne left the dress with me at the end of the session so I could paint its flowered pattern at my leisure. I'd paint her hands later, using my own as models.

I painted the fabric of her sleeveless dress with a low tonal contrast to the background so that the garment's subtle design was more felt than seen. When I tested the contrast by squinting, the color and the detail vanished. This is a desirable effect.

Hands aren't difficult to render if I paint only their tones and shapes without thinking about the hands or fingers. If I think about hands, I stop immediately. And I don't fall into the trap of creating too much detail, so feeling isn't lost. The hands magically appeared, and I made my Nefertiti's large, like Rembrandt's paintings of women's hands, to show power. I lightened the darks that separated the fingers as a way to make the separation subtle. This had to be a carefully orchestrated monochromatic painting before color was added.

When I was satisfied, I set the painting aside for a few days to dry.

Daphne returned for another session. Because the background was relatively cool, the skin colors I would use now were flake white, yellow ochre,

cadmium red light, and ultramarine blue, mixed in various proportions to achieve subtle warmth. A bit of experimentation was needed here, and when I found the right colors, I prepared too much rather than too little, because when I'm on a roll, it's frustrating to have to stop to re-mix colors.

"I'm curious about these rectangles," Daphne said. "I'd like to know more about the technical side of painting."

"Okay, you asked for it. I'm painting you against a background of drapery, but I try not to look at the painting as a figure and background, only as warm and cool masses that I make lighter or darker. The masses are composed of barely visible overlapping planes made up of points and lines that give depth to the work. I don't put a mark on the canvas unless it makes something happen, and when something isn't right, it grates on me. It's perplexing to decide what to emphasize, what to de-emphasize, and what to leave alone."

"You're like a choreographer devising dance steps for a ballet," she said.

I glazed on color in thin transparent layers. I perfected the shadows and the warms and cools, scrubbed out places that lacked subtlety, and re-glazed, but something wasn't right. The hair, perhaps? Knowing that one side of anything should be different from the other, I sharpened the hairline on top of her head and fuzzed out the hair on the back of her head. The hair was improved, but it wasn't the problem. She needed an earring, a pearl one that would go with her dress. I painted it in.

And still, the problem persisted.

I turned the painting to the wall, came back to it days later and discovered things: a shadow under the nose needed to be lighter, a shadow behind the ear, darker. I toned down a distracting highlight on the chin, but something still wasn't right. Ai-

leen heard me mumbling.

"What's wrong now?" she asked.

"The book in her hands is too intellectual."

"What if it's a book on poetry?"

"How will the viewer know?"

"Identify the book."

"That's too trite. Anyway, the shape, it's too harsh. It doesn't work. A red rose in her hands would symbolize true love that will stand the test of time."

"My, aren't you the romantic. But isn't it too late to change anything?"

"It's never too late."

"These are the most beautiful hands I've ever seen you paint. They look as good from across the room as they do up close. Are you sure you want to paint them out? And the book?"

"I know it's a major change, but it has to be done. Didn't Rembrandt repaint his Danae? He repainted her hand, her arm and her face! What did he care about how long it took or how painstaking the alteration would be?"

"How do you know all this?"

"X-ray studies in my Russian book show how Rembrandt modified his compositions and handled the lead-white under-paintings. His original Danae, lying in bed, has been changed. The radiographs show that the first head, which was rounded and snub-nosed, looks more like his wife, Saskia, than the present Danae."

I painted out the book, restored the flowered pattern of the dress and repainted the hands in their new position, but I made the hands smaller so they wouldn't dominate. You'd need an X-ray to see what was there before. The painting was put aside for another week of drying.

The model was no longer needed. The work required more glazing, thin transparent washes,

layer upon layer, making sure what's underneath showed through; that's what makes a face vibrate and seem alive. It takes a few seconds to apply a glaze but hours for it to dry. I made sure light would come to the viewer's attention first, then color, middle tones and dark tones. If color pulled attention away from the light, the painting would have a burnt look. I wouldn't let that happen.

The final highlights on the forehead, nose and chin were tricky. I painted them in, but they were not satisfying. Out they came with the help of a palette knife and the corner of a rag dipped in turpentine. In they went again. After three tries I was happy. But now, something else wasn't quite right. The red on her lips was too insistent, but the lips were too beautiful to change. A darker red on the V-neck of the dress would pull attention away from the lips. Years ago I wouldn't have dared to soil the dress with a red spot, but this was a "move the eye" mark with a specific purpose, and it worked.

In her clasped hands, I painted a rose. But the hands, even though smaller now, overpowered the rose, so I toned down the hands little by little with muted transparent grays until they almost faded into the background. But something else had to be done, and I wasn't sure what. Frustrated, I lifted the painting off the easel and turned it to the wall. Maybe fresh ideas would come in a day or two.

After several days it occurred to me that the long vertical of Daphne's body needed to be neutralized by a horizontal. I painted a table behind her at the level of her horizontal forearm, but it attracted too much attention. No matter what I did, something else had to be done. I was frustrated. Sure, I could run to my artist friends and seek their advice, but I wanted this painting of Daphne to be 100 percent my own.

Aileen put on a pot of coffee, surprised me with a bagel and lox — Jewish medicine — for lunch. Frustration was replaced by logic. Often, when I'm into a painting, there inevitably comes a period of anxiety, bordering on torture, and I have no choice but to struggle on, experiment, fail, and start over. I'd start by reviewing what I had learned over the years.

Finishing or artist's touches are more than highlights or dabs of intense color that move the eye. They can also be diaphanous marks to enhance illusion. It's often difficult to know where and what to exaggerate subtly. How much to exaggerate is a decision you and I will have to make on every drawing or painting for the rest of our lives. A teacher once said, "A magician succeeds because he has learned and practiced a series of motions that he executes with grace, precision and dramatic ease. He has eliminated, juxtaposed and exaggerated the logical order and created an illusion. The artist does the same. Drawing and painting are two forms of the same illusion."

Pablo Picasso said, "Painting isn't an aesthetic operation; it's a form of magic designed as a mediator between this strange hostile world and us." How do I find my magic? I decide to get help from the masters by looking through my art books for portraits that move me. Some are so enthralling that they keep me from turning the page. But why can't I turn the page? What is it that mystifies me? It has to be in plain sight in each painting, but I can't see it!

I've copied paintings that move me: Edouard Manet's *Portrait of Stéphane Mallarmé* and Pierre-Auguste Renoir's *La Loge*. It's hard to pull myself away from my own original painting, *Lady with Derby Hat*, (Figure 5.2) which I finished years ago.

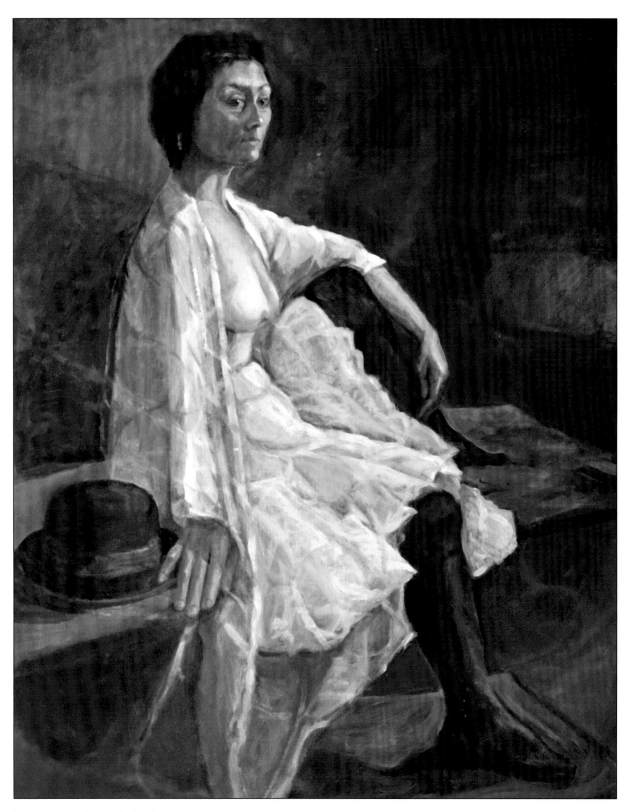

Figure 5.2. *Lady with Derby Hat*.

How can my own painting mystify me without my knowing why?

More days passed. In bed between wakefulness and sleep, something came to mind. This happens often, and usually I'm too comfortable or too tired to turn on the light and write my idea down. I think I'll remember it in the morning, but I seldom do. This time I was prepared. A pad and pencil lay on the nightstand. I flipped on the lamp, wrote "Block out derby," and went to sleep.

*Lady with Derby Hat* had provided the solution for how to fix the picture of Daphne. The dour expression of the model who posed for *Lady with Derby Hat* had transformed her into an indignant hooker, sitting on the hard wooden bench of a jail cell, but I omitted the bars, leaving the painting open to a different interpretation. She was wearing a frilly white outfit that was open on top, exposing her breasts. Her dark hair and black stockings harmonized with the black derby hat lying next to her on the bench.

The painting doesn't work as well if I eliminate the derby by covering it with my hand. It wasn't one of the model's props, but I felt that a prop of some sort was needed. I wasn't sure what or where or why. It's easy to talk about something you've already done as if it were planned, but this wasn't planned. Maybe I got the idea from old movies or a play. The derby was in a carton of props for Pretenders' Playhouse, the community theater group I was in. It harmonized with the hair and the stockings, and its roundness repeated the shape of the top of the model's head and her knees, which stick out prominently. The light band around the derby added a note of femininity. Even the red artist's touch of the flower I added to the hatband worked. But I didn't think about any of those things at the time, I just painted the

derby where I thought it belonged. It serves as a necessary distraction or conflict, drawing my eyes away from the face so I won't get stuck there, but it lets me get back.

In my copy of Manet's *Portrait of Stéphane Mallarmé* (Figure 1.25), the face and the pose are striking, but if I cover the right hand holding the smoking cigar and the book the hand is resting on, the painting loses power, because I've covered up the distraction that's needed to move the eye away from the face and back again.

What about a complicated painting? In my copy of Renoir's *La Loge* (Figure 5.3) I'm drawn to the woman's face, wondering how his attractive model, Nini, got the name Fish Face. With my hand, I cover the flowers in her hair, and now her bodice competes with her face. I cover her necklace and bracelet, and I'm pulled this way and that, unable to focus properly on what Renoir intended. The man behind her — the dark parts of his clothing blended, connected and unified with the dark parts of hers — is the distraction. If I cover nothing, my eyes take in the whole painting, travel from place to place, focus on the face but don't get stuck there. If I cover the man, the painting doesn't work as well. I can't take anything away from these paintings without damage to the composition. Every mark has a purpose.

The answer to finishing the painting of Daphne burst upon me the next day when I was in the shower. I dried off, dressed, and mixed the paints. Before I even touched brush to canvas, I saw the finished painting in my mind's eye. Daphne's gaze needed an additional object to give the painting a fourth dimension, a distraction as mysterious as her face. On the table behind her, there needed to be a suggestion of a round fishbowl with an undefined goldfish swimming

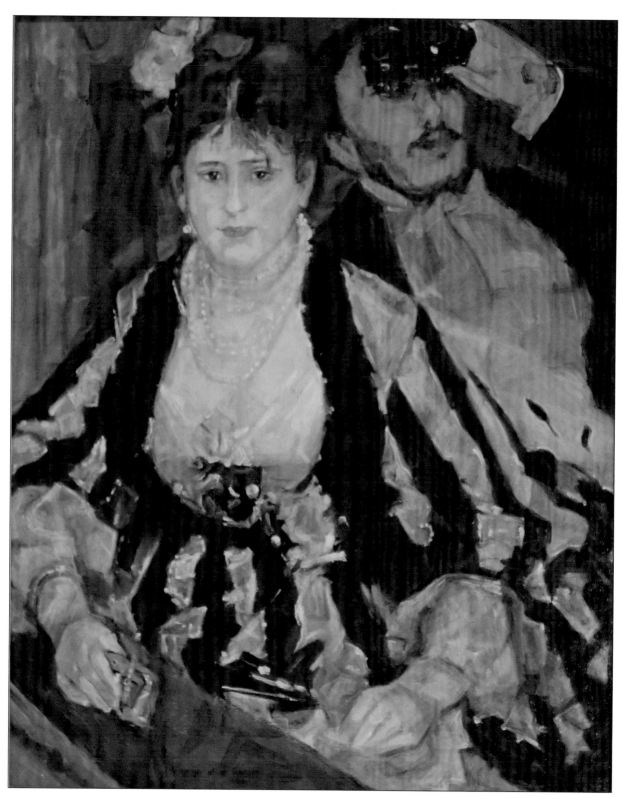

Figure 5.3. My copy of Renoir's *La Loge*.

in it. Then the table wouldn't be empty. I painted quickly, added a slight smudge of deeper orange to the gills, stood back, scratched my head. Almost there. Almost. I put my hand over the fishbowl, and the painting lost its magic. I took my hand away and the magic returned. But Daphne's face needed an imperceptible something. I warmed up her cheek with Blockx vermilion, purchased at a precious price, and rubbed my pinkie on it to spread the paint. The light around the figure vibrated. I could almost see Daphne's chest rise and fall. I became a boy again, sitting on a bench in the middle of the Rembrandt room at the Metropolitan Museum of Art in Manhattan, wishing I could paint a portrait that looked as if it were breathing. I couldn't have done it without help from the masters, especially Rembrandt. I could almost feel his hand on my shoulder.

I entered Daphne's portrait in the Napa Exposition, one of 90 or so annual county and city fairs in California, where it won "Best of Show." All that torture had finally paid off.

Of course I couldn't get enough of Daphne. I painted another portrait, which I gave to her, and the following formal portrait *Daphne in Black Dress*. It worked better after I added the earring and the red bow.

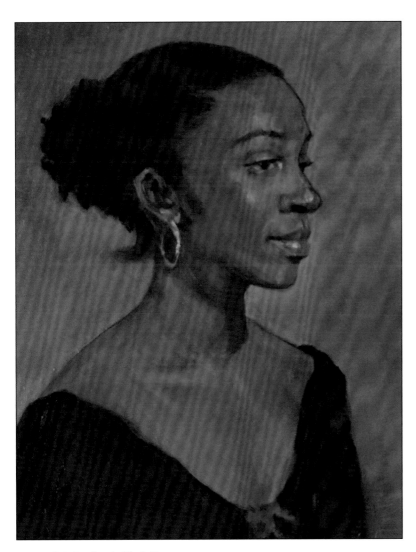

Figure 5.4. *Daphne in Black Dress.*

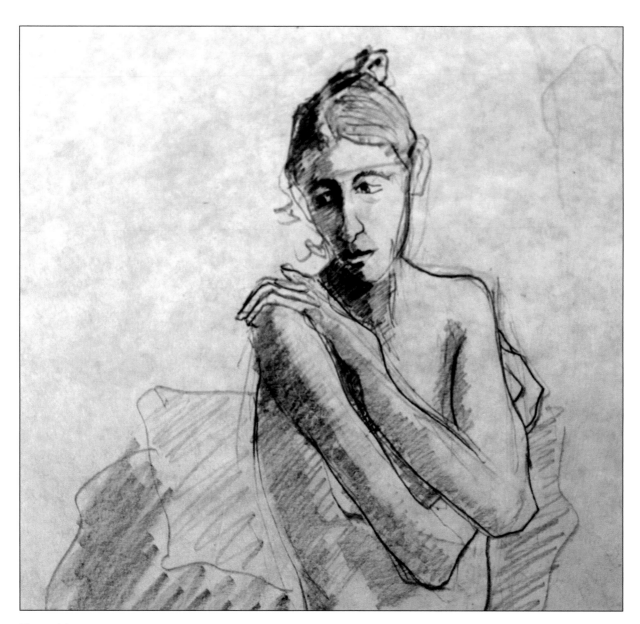

Figure 6.1.

## Cutting Free

"It's a curse. Yes, it's a flame. It owns you. It has possession over you. You are not the master of yourself. You are consumed by this thing."

— *Henry Miller (1891–1980)*

Jon, my artist friend, lives in a shantytown five miles from Napa. My teacher, Bill, and another artist friend, Helen Kask, live there too, but it's not an artists' colony, just a place poor people can afford. The road leading there curves along vineyards, orchards and cattle ranches with tumbledown barns. Going there is like driving through a Camille Pissarro painting.

The pavement ends abruptly at a dirt road paralleling the river. I drive through a cluster of World War II prefabricated plywood houses, passing rusty vehicles, unseaworthy rowboats used as beds for flower gardens, and an old building with a rusty anchor in front that serves as a cafe, post office, bait store and bar. Most of the houses haven't been repainted since World War II ended. Their walls still bear traces of battleship gray. Strips of duct tape slant across cracked windowpanes, but the area is anything but drab. Geraniums hang from wire baskets, bougainvilia climb the walls, colorful banners wave in the breeze. And wind chimes proclaim that this is a special place. It certainly is for me. I come here once or twice a week to study art with Bill. In any direction you look there's something to paint. There are enough subjects in the shantytown to keep an artist busy for a lifetime.

Two houses are in better shape than the rest. One's a garish purple. Helen's place is a bright yellow. She painted it herself. She says the purple house does a better business than the bar. Jon's shanty is next to the bar. Jon is a huge guy, and everything he does is big: full sheets of watercolor paper, giant canvases, a fresco on his living room wall. He uses house-painting brushes, paint rollers, trowels, even his large hands. His back yard is a sculpture garden. There are heavy wire skeletons (armatures) that are ready to become life-

sized plaster sculptures of the neighborhood children. Jon lets the shantytown kids paint or clothe or otherwise decorate his sculptures. It's good to have a brave, creative friend who experiments with different media. Every visit inspires me.

Jon is the most creative person I know, and like many creative people he's eccentric. He doesn't care what people think about his art or his conduct. He sees the abstract and the specific at the same time in everything he deals with, and he has a knack for unifying dissonances such as colors that clash or any other parts of a painting or sculpture that fight each other. He has no inhibitions. When we went sailing in my 23-foot sloop, we got stuck in the mud in the Napa River near Vallejo, and he immediately took off all his clothes, jumped in and towed us to deeper water. His drawings and

sculptures are beautifully inexact. His creativity is improvisational, like jazz or children's art.

I used to be more obsessional than I am now, constantly training, self-criticizing, a perfectionist.

The psychologist Abraham Maslow says, "… great work needs great talent … great work needs not only the flash, the inspiration, the peak experience; it also needs hard work, long training, unrelenting criticism, perfectionistic standards." That sounds like me as a dental student and as an early art student, wanting to learn all I could about human anatomy. The articulated skeleton in my studio is handy for studying bony landmarks (Figure 6.2). Sometimes I superimpose the image of a skeleton over a drawing, but first I have to mimic the pose by supporting the skeleton's limbs with clear fishing line attached to hooks in the ceiling of

Figure 6.2.

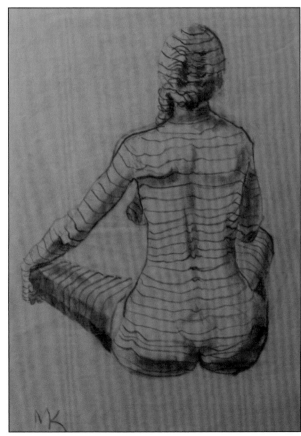

Figure 6.3.

my studio. In Figure 6.3 parallel lines were projected onto the model's back as an aid in visualizing its curvature.

When art students complain about a lack of time, I tell them their problem is not lack of time, it's lack of time well spent. Often, they spend too much time making their work too clean, too precise. Buildings look as if they're pasted on. I should know. I went through the same phase.

"When are you going to break yourself open and be free and paint with your soul?" I ask them.

"How do I do that?" they ask.

"Stop thinking precision," I tell them. "It's not about precision. It's about instinct and passion and taking a leap into the unknown."

I have to remind myself to follow my own advice.

I call my friend, Helen, the Mary Cassatt of Napa, after the Pennsylvania woman who went to France and became one of the great impressionists. On Helen's walls are pencil, pastel, oil and watercolor studies of the brothel women from the purple house in various stages of undress. Her watercolor washes over ink drawings are done with a freedom and looseness that I have yet to attain. I find it helpful to paint in the company of other painters, and when I paint with Helen *en plein air*, she sees three times as many colors as I do in the blandest of rocks, earth and grass. She paints daringly, inexactly, and quickly, and her subjects, whether people or places, look real. I own *Twin Sisters*, her watercolor wash over ink (Figure 6.4). She knows how much I admire her work and that of our mutual friend, Jon.

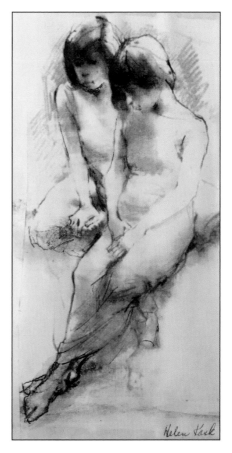

Figure 6.4. *Twin Sisters*, by Helen Kask.

"All he talks about is your devotion to detail, your strict adherence to art principles," she tells me. "Jon is as much in awe of you as you are of him. You're learning from each other. I see it in your work. Jon needs a bit more of your perfectionism and you need a lot more of his *laissez-faire* ways."

Over the years, in weekly three-hour sessions, I drew Figures 6.5 to 6.16, but none were as *laissez-faire* as Figure 6.1, which I drew later at a session with Jon.

My teacher, Bill, lives a block away from Helen. Although they admire each other's work, they don't get along. Clash of personalities. "When are you going to quit studying with him?" she asks.

"Not now. Bill knows so much, and I have so much yet to learn."

"There will always be more to learn. But some day, and I hope it's soon, you'll have to cut free of him and solve your own painting problems. Only then will you really mature as a painter."

Cutting free? I couldn't bear the thought of it then, but years later, I became brave enough to do so. I wish I had followed Helen's advice earlier. Some day you will have to decide when to cut free.

Figure 6.5.

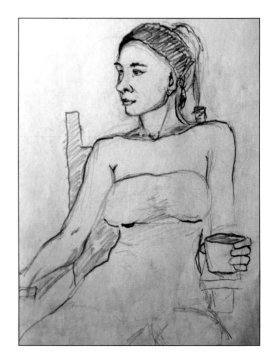

Figure 6.6.

Figure 6.7.

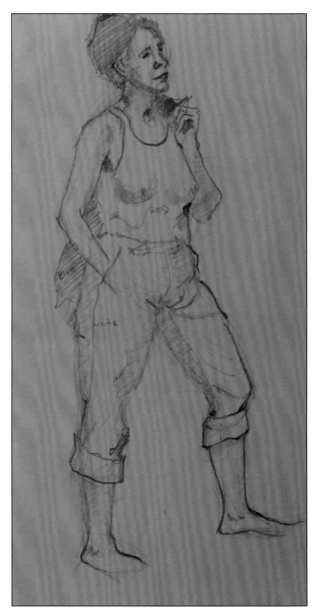

Figure 6.8. *Clothed Standing Model.*

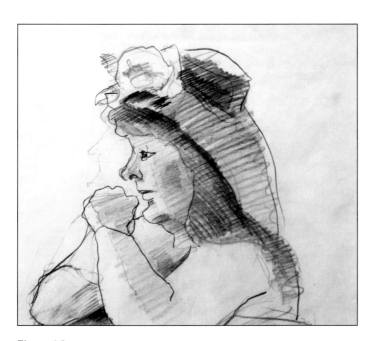

Figure 6.9.

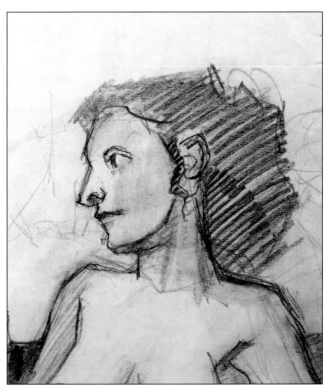

Figure 6.10.

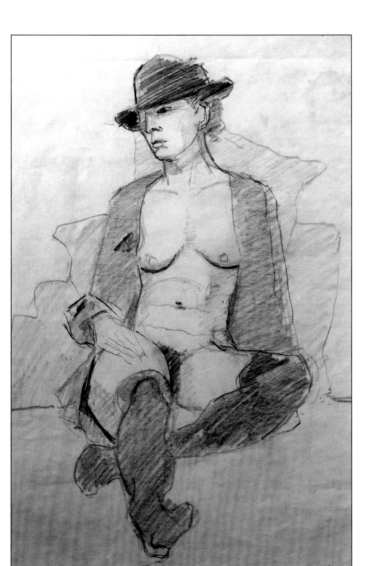

Figure 6.11.

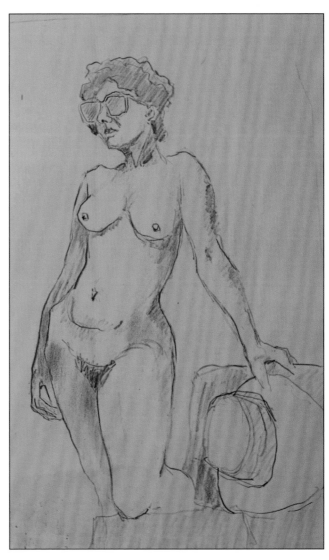

Figure 6.12.

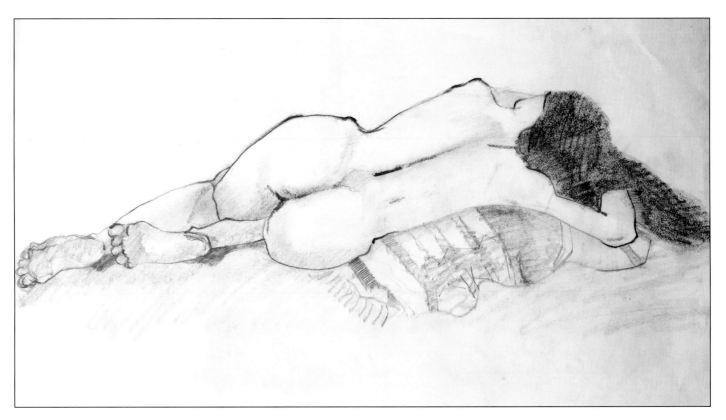

Figure 6.13.

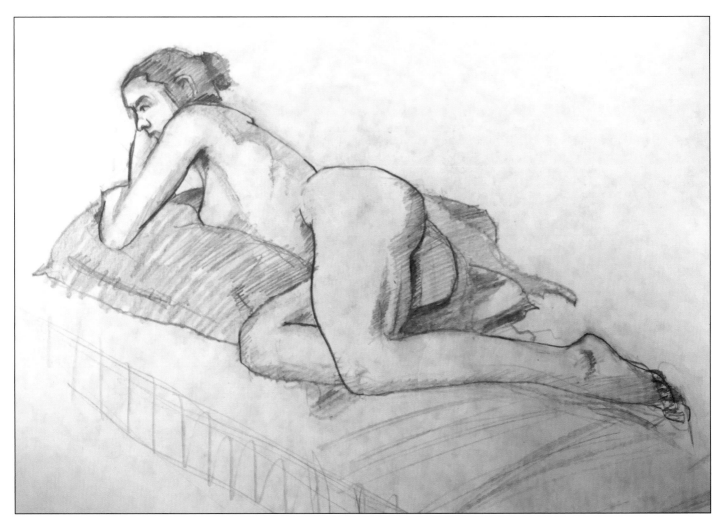

Figure 6.14.

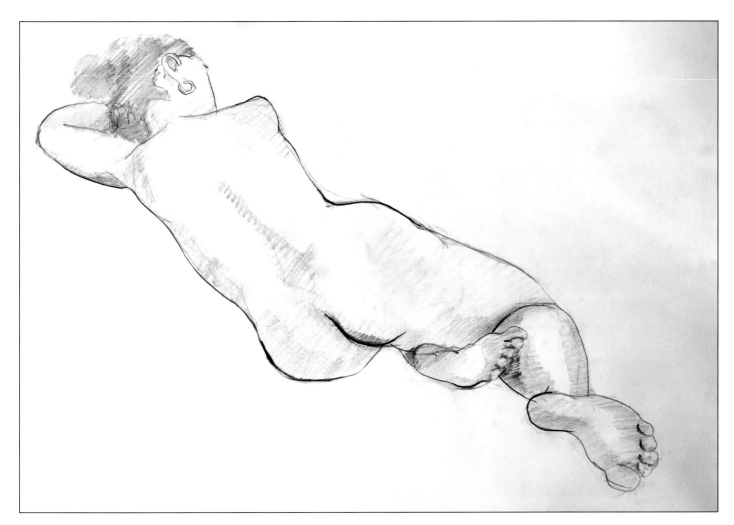

Figure 6.15.

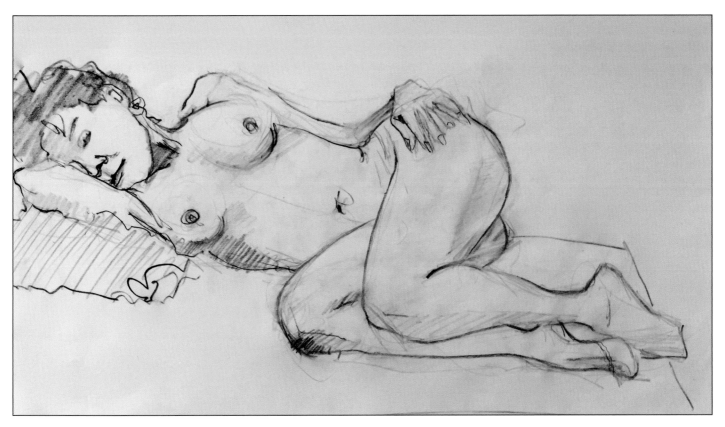

Figure 6.16.

Figure 7.1. *Black Angus.*

## Music to My Brush

"Nature contains the elements, in color and form, of all the pictures, as a keyboard contains the notes of all music. But the artist is born to pick and choose … until he brings forth from chaos glorious harmony …"

— *James Abbott McNeill Whistler (1834-1903)*

Dvorak's *Largo* solo from his *New World Symphony* is my music of choice today, but it's not coming from my tape player. My pal Jim is sitting in a chair on my studio modeling stand, playing his English horn, rehearsing for a Napa Symphony performance while I paint his portrait. (You can see a quick sketch I did of Jim playing the English horn at the actual symphony on page 15.) A flow of melody is woven throughout the music much as Whistler wove threads of color throughout his paintings to unify them. There's a direct relationship between music and painting. They have their own colors, rhythms, tones, harmonies and contours. Listening to music while painting isolates me from the worries of the world, soothes my soul, and brings out the best in me.

I feel the euphoria Dvorak must have felt when composing this piece, putting marks on pa-per, erasing them, making new marks, telling the musician to play louder, softer, faster, slower, with more nuance, with more life, so the concert-goer would get his moneysworth. With a paintbrush in my hand, I'm doing the same thing, guiding a viewer's eyes through my painting, giving priority to objects in a scene, avoiding chaos.

### Guiding a Viewer's Eyes Through a Painting

Let me show you how I do it. It's best explained with landscapes, and while I paint today, Vivaldi's *Four Seasons* is my mood music.

Geometric shapes are more interesting when they have varying lengths, widths, sizes and col-ors. Since I don't want your eye to jump from one object to the other, creating an easy path for the eye to follow makes sense. The path need not be a river or a road, although rivers and roads can

Figure 7.2. Manet's *Races at Longchamp*.

be useful diagonals for entering a picture plane and traveling from foreground to background. The path can be graduated and unconnected, but your mind will connect it if the path leads from small to large, light to dark, or along a series of related shapes. The path can be suggested by an arrow-shaped shadow, a pointing finger or the direction of Daphne's gaze. Even brushstrokes can move the eye.

I don't want my painting to be seen as happening all at once! If your eye zips through it, you will quickly finish with it and move on to the next painting. To prevent this I must provide rest areas, places of ebb and flow, little side-trips away from the main path to slow you down. But I'd better not make these rest areas too intense. If I do, you might get stuck somewhere, unable to get back. It's a delicate balance. Like a conductor leading musicians through an overture, I must control

the pace at which my painting reveals itself to the viewer.

The eye travels more slowly over lost and found lines than solid ones, over gradual value transitions than sharp ones, and down winding paths than direct ones. It's a matter of using the elements of art wisely and creatively. The path must be smooth but rhythmical and point to thought-provoking things along the way, places to rest a while before going on. Achieving this requires planning, and the more things planned ahead of time the better.

Consider edges when guiding the eye. Edges can be hard, soft, lost, jagged, rough or double. Hard (focused) edges are clear and attract the eye. They consist of sharp lines, contrasts between complementary colors or between dark and light. The dominant part of a painting will certainly contain a sharp edge or two, which evoke tension.

Soft (out of focus) edges are like those found

in clouds, nudes, children and tree leaves. Areas between the dominant parts of a painting must be soft and sometimes fuzzy to slow down eye movement. If all areas were hard, the viewer would be disturbed. If all areas were soft, the painting would look weak and dull. It's up to me to provide dominance and areas of rest and not allow the viewer to get stuck somewhere. Softness can be accomplished by weak contrasts of color and shade, subtle hatch lines that produce a jagged edge, applications of analogous color (colors that are next to each other on a color wheel) that make edges look out of focus, and applications of color lightly brushed over rough canvas or rough watercolor paper, contacting only the hills but not the valleys of the grain. All the edges have to work together rhythmically. While painting, I continually modify edges until they feel right, which is easier to do in oils than in watercolor.

If tones or colors are too close to be distinguished from each other, lost edges happen, which give the viewer places to rest before traveling on. These areas, by comparison, make the dominant area more dynamic and interesting.

Figure 7.3. Degas' *Le Défilé*.

Figure 7.4. Degas' *Le Faux Depart*.

## Animal Instincts

Different scenes demand different kinds of music. I enjoy painting at the end of Henry Road, on the outskirts of Napa, a timeless place with no traffic, and not a single kibitzer standing behind me, just foothills, oak trees, shadows and a mossy wooden fence. I have my MP3 player with me, but I don't turn it on. The sounds of the farm behind me are my music today: roosters crowing, horses snorting, a tractor plowing.

Figure 7.5. *Horse Race.*

After my thumbnail sketch, I paint the shadows cast by the trees on the hill in front of me before they change. Then I paint the trees. But something isn't right. Landscapes must have a dark that extends from one side of the picture to the other, creating a sense of containment. So I paint in the herd of grazing Black Angus cattle that are usually here (Figure 7.1). Problem solved.

Study master landscapes and imagine them without the darker values that tie one side of the painting to the other. Would they work as well?

Once, I asked my teacher how to paint a cow. He said just paint a box and put legs on it. That was a start, but how does one paint an animal in motion? The impressionists will tell us. In Manet's *Races at Longchamp* (Figure 7.2) dozens of trackside figures are foggy, and only two are clearly rendered. The leading horses and riders have crisp outlines, others are out of focus, but Manet has captured the essence of a horse race. In *Le Défilé* (Figure 7.3) Degas has rendered the horse's legs in the right foreground perfectly, letting the viewer imagine that all the legs are skillfully painted. And in his *Le Faux Départ* (Figure 7.4) he painted grace and movement, which is more artistically important than accuracy of leg position. The masters took artistic liberties to enhance their paintings.

Let's go to the racetrack. Enjoy the thrill of the bugler's "Call to the Post." Bring your camera to take impromtu pictures of visual music: a

Figure 7.6. *The Harness Race.*

symphony of jockeys in colorful silks atop sleek horses, riding to the starting gate. Race officials, touts, gamblers, gawkers. People in the stands with cameras, racing forms, binoculars. Lines of bettors, still at the windows, placing last-minute bets.

If your best photos are used for inspiration, rather than laboriously copied, they'll be useful, but it would be better to sketch and try to capture the essence of the track without relying on photographs. Of course, the horses aren't going to stand still while you sketch them. This is the time to plug in your earphones and listen to something snappy like Jacques Offenbach's *Can-Can* from his *Orpheus in the Underworld.* It will help you to quickly capture movement and gesture. It should

only take a few seconds. A horse is also a box with legs. That's two seconds more. If you practiced that a thousand times, you'd be good at it. Degas did his homework before he produced his masterful paintings and sculptures of horses.

Somewhere in your pages of sketches will be some little gem that you can elaborate upon at home. There are two excellent books, *Modeling and Sculpting Animals,* by Edouard Lanteri and *Animal Painting and Anatomy,* by W. Frank Calderon. If you're serious about drawing or painting large animals, those are the books to study. Modeled anatomical studies of the horse in different positions would be helpful in understanding muscles and the distinctive shapes that will transform your box into a horse.

A key lesson I learned from these books can be summed up by the painter Gérôme: "When a sculptor starts a figure, if he has carefully taken the principle measurements, and accurately indicated the prominences of the bones, he is astonished to see that, though there is as yet only uncouth masses, there is already a resemblance to the model, that the work is already well advanced and that its completion is only a question of hours and of work."

My first watercolor of a horse race (Figure 7.5) looks amateurish. It needed a third overlapping horse. *The Harness Race* (Figure 7.6) is my first oil painting of horses, inspired by a race I saw at the state fairgrounds in Sacramento. Mud is flying, the leading jockey's whip is flailing, the crowd is cheering. Some parts are fuzzy; others are crisp. I added lines parallel to the horses' feet to enhance the illusion of movement. But despite some pleasing parts, it's not up to my current standards. The face of the rider on the left should have been turned to a straight-on view. The wheels of the sulky and the horse should have been parallel to the line of the fence. Neither painting was worthy of a signature, but I left them on my wall long enough to be annoyed by the mistakes. Why am I pointing out failures? Because I learn from them. They are the keys to success.

To produce a symphony, it takes a composer to write it, musicians to play it, and a conductor to guide the players through it. A painter wears all three hats to produce his work. But when he teaches, he is a conductor. Aware of his students' unique gifts, he leads them along different paths at speeds consistent with their ability. I couldn't have drawn a cow or a horse without first drawing a box with legs.

Do you listen to music while you draw or paint? Do you employ the elements and the principles to guide your viewers' eyes through a painting? Can you speed up or slow down eye movement? Do you study the work of masters to see how they did it? Is there a pile of library books on your table? If so, you are well on your way…

Figure 8.1

## The Creative Leap

"The aim of art is to represent not the outward appearance of things, but their inward significance."

— *Aristotle* (384 BCE - 322 BCE)

For a radical change of scene and painting opportunities, let me take you down to Mexico and a painting trip I took some years ago with Aileen.

We're in line at the airport in Guadalajara, Mexico. An inspector rifles through my travel bag, opens my miniature metal watercolor palette, snaps it shut, smiles, says artista, and sends us on our way. I'm suddenly in the clouds, empowered by that magic word, "artista." It's how I felt years ago when my teacher Bill said he saw something in my work and knew I'd become an artist some day. It's important to have someone on your side who believes in you, encourages you, gives you an occasional pat on the back. I promise myself to never do anything to discredit that exalted title of artista.

Whether traveling by plane, train, bus or burro, I've committed myself to spending at least three hours a day with pencil or brush, capturing the essence of the country. We're also going to visit an expatriate friend who lives in San Miguel de Allende. We'll go there on a roundabout way to take in as many sights as possible.

At three in the morning, the train station in Guadalajara is crowded with humanity and a few goats on leashes. The only sounds are from snoring men and crowing roosters. While Aileen sleeps with her head on my shoulder, I sketch a man curled up on a wooden bench, his head tucked in his wife's lap. Then I sketch and paint a watercolor of a mother and child lying on a red blanket on the floor. Their eyes are open. Maybe the roosters are keeping them awake (Figure 8.1).

On the train at 6 a.m., I furtively draw another family sitting across the aisle. The mother is plump and pregnant. Her face is angelic. Her handsome husband wears a pencil-thin moustache. His hand is on her belly, and he smiles, perhaps feeling his unborn child kick. His young daughter sits on his lap, squirming. Earlier in my painting days, when

Left: Figure 8.2. *San Miguel de Allende.*

drawing a similar scene, I'd do three different views of the child in her yellow dress, waiting for the appropriate view to appear, but I didn't feel like an artist then. An artist doesn't wait for the proper view to appear, he goes for it immediately after memorizing what he sees. At first, he might be pitifully poor at memorizing, but with practice he gets better and better.

These days, I don't care if subjects move at critical moments. I look at the child, draw her gesture, and working from the whole to the parts of the figure, state important information. After another glance, another bit of memorization, I place a few pencil strokes to define her features. It now takes me three minutes to produce an acceptable likeness.

Aboard the train, an ancient Indian with creased skin as dark as walnut stands tall and proud in the aisle. When a young man offers him his seat, the Indian tips his white sombrero and refuses. His hands, holding the top of a backrest, are gnarled and bony. I capture his gesture, figure, face, sombrero and bony fingers in ink on an 8 x 10-inch D'Arches watercolor pad. The procedure is part of me now, and magically built into the drawing are ellipses and form over form. I suggest the windows and the seated passengers across the aisle, then add color washes, saving the white of the sombrero.

I've learned something big today. The bouncing train has made it impossible for me to put down my usual "correct" lines, which deaden the drawings. My "incorrect" marks, by contrast, are lively and vital and add to, rather than detract from, my rendering of the child on her father's lap and the Indian standing in the aisle. At home, I'll either have to quit making "correct" marks or draw only when I'm on public transportation. Spontaneity is the lesson here. I've already absorbed technique. Now I must surpass it if I hope to become an artist rather than a technician.

Aileen and I find pleasant surprises as we stroll through the center of Mexico City. In the Hotel Prado's lobby we discover Diego Rivera's famous mural *Dream of a Sunday Afternoon in Alameda Park*. In the Casa de Azuelos cafe, where we have coffee and dessert, we find Orozco's mural *Omniscience*. We walk around the Zocalo, or square, see the stately 17th century buildings and observe dozens of workmen with signs advertising their trades, waiting to be hired. I'm getting a taste of local social realism.

Figure 8.3.

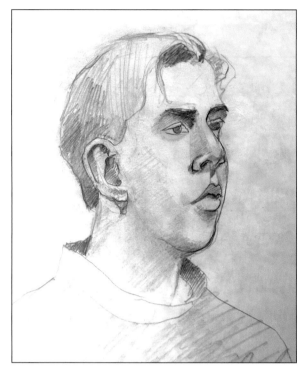

*F*igure 8.4.

The Mexico City light is different. I sketch cathedrals and add color washes. We ride the Metro just for fun and get off at random stations to snoop around and to snap photographs that I can later turn into paintings.

The big three Mexican muralists, David Alfaro Siqueiros, Diego Rivera and Jose Clemente Orozco, believed that art is for the education and betterment of the people. The work of Siqueiros, a socialist, was directly influenced by and was an expression of the Mexican Revolution. He preferred murals. He felt that easel painting was aristocratic, that only monumental art should be glorified, because it is public property. This morning, we're in the Museo del Palacio de Bellas Artes, looking up at Siqueiros' huge masterpiece, *New Democracy*, which portrays democracy as a vigorous bare-breasted woman with red lips, wearing a Phrygian cap, who is bursting forth from bondage, breaking chains that are still shackled to her

wrists. The figure seems to pop right off the wall. She carries a flaming torch in one hand and yellow and white flowers in the other. A third arm, with a clenched fist, hovers over a prone figure depicting defeated Nazism. There's nothing like seeing a powerful painting in a museum. The master conveys struggle, liberation and violent social protest with chiaroscuro, dynamic brushwork and heroic themes. All artists would profit from studying these Mexican muralists who were angry enough to shock a complacent world.

Next stop, a six-hour train ride from Mexico City, is San Miguel de Allende, a source of fresh stimulus. Light and color is the lesson here. "The city has no fast-food restaurants, no advertising signs. It looks the way it did a hundred years ago," our friend, Michael, says. There are narrow cobblestone streets, red and purple bougainvillea shrubs and stucco houses painted in subdued shades of cinnamon, aureolin and vermillion.

Modern autos share sunny roads with burros laden with firewood.

I find time to visit the Escuela de Bellas Artes where Siquieros taught and to sit in on a drawing session at the Instituto Allende, where twenty or so artists are drawing a nude woman. I draw the model quickly, feeling that I'm pulling out the lines from deep within me. I don't waste my time and energy being intimidated by the work of some of the artists there who are more advanced than I am. It's constructive to emulate superior work, but it's disempowering to let yourself be overwhelmed by it. And I certainly don't gloat over the less-talented artists. I've been there.

Here's a watercolor study I painted the next day, an outdoor café built around a tree (Figure 8.2), which for me, captures the essence of San Miguel de Allende.

In the evening, we sit with Michael in the main square, El Jardin, listen to guitar music, and watch young men and women promenade around the square in opposite directions, as is the custom here. Next morning in El Jardin I sit on a park bench, watercolor pad on lap, and along with other artists, paint the pink sandstone church across the street, La Parroquia de San Miguel Arcangel. The original façade deteriorated over the years and was replaced by a gothic façade designed by a local mason/architect who got the idea from a picture postcard of a European church.

A boy of about 10 has been watching me paint. He looks bright and so deadly serious that he reminds me of myself. I'm still a bit uncomfortable when people watch me paint. Is it because of my fear of falling short of their expectations? Should an artist even be concerned about a viewer's expectations? But there is something special about

Figure 8.5. Rubens' painting, *Old Woman with Pan of Coals* (detail).

this boy and his unstated expectations. I can feel it. He will become an artist some day.

When I apply the finishing touches to the church, he asks me, in words and sign language, if I will paint his portrait. Of course I will. I sketch his face on my watercolor pad, wishing I were doing it aboard the bouncing train (Figure 8.3). One sketch isn't enough. I draw another in three-quarter view (Figure 8.4).

My lines are free-flowing and spontaneous. I'm not trying to put on a show for the boy, but his eyes are open wide with amazment. I feel more like a magician than an artist. Then it occurs to me that an artist is a magician. I select the drawing I want to paint. Then I mix the colors. If the boy should ask me why I stare at my sketch for a few moments before painting, I'll tell him that I think before I paint and then paint without thinking.

The immediacy of watercolor appeals to me. I don't labor over details. The less effort I put into rendering the boy's eyes, for example, the better they become, even though they're more suggested than painted. I'm purposely a bit sloppy in order to disguise the Principles of Art. I use lost and found edges, leave brushstrokes undisturbed, blend strength and subtlety, and leave something for a different interpretation as in *Lady with Derby Hat* (Figure 5.2). The watercolor of Aileen (Figure 4.5) was done this way.

When I'm done, having painted the boy's portrait somewhere between clarity and ambiguity, he says, *"Yo quiero ser un artista cuando sea grande."* (I want to be an artist when I grow up.) With a broad smile, he runs off with the portrait and returns with his mother, who offers me a basket of fruit as payment. I tell her there's no charge. Seeing the boy's eyes light up when I handed him the painting was payment enough.

What I am saying right here is this: Learning all the necessary techniques of painting is essential. Those are your tools and your foundation. But to be an authentic artist, you have to go beyond technique. You have to discover your own personality and your own voice as an artist. This is not easy. Far from it.

Early in my studies, I ran to Bill when I had an art problem that I couldn't solve. He'd improve a watercolor with a few brushstrokes, or a drawing, with a few well-placed lines. Then he'd say my work was great, but it just needed a little something extra. His validation of my work pleased me, but I never felt that my work was my own.

My greatest love is portraiture. I'm driven to do it. So when it came to paintings of family or friends, I wouldn't let Bill touch my canvasses. I needed the inside validation of knowing that the work was performed by me alone. One day I was thumbing through a Rubens book, and I discovered his *Old Woman with Pan of Coals* (Figure 8.5). I had to paint the old woman's fascinating face. I worked on it for six hours, concentrating only on the tonalities and the shapes of the light and dark areas. I was in some sort of trance, like I feel sometimes when I'm running. I'm told I had an endorphin high. The time passed quickly, and the painting was an exact reproduction. I still don't know how I did it.

The painting of Shelly, a granddaughter of mine by marriage, was done the same way (Figure 8.6). I was a bird that had just learned how to fly. And once I had mastered technique and gained confidence in myself, those were the only rewards I needed, the joy of flying and the accompanying sense of fullfillment. And gaining those feelings are my highest wish for you.

Figure 8.6. *Shelly.*

Figure 9.1. My copy of Rembrandt's *The Old Jew.*

Figure 8.6. *Shelly.*

Figure 9.1. My copy of Rembrandt's *The Old Jew.*

## Lessons from Rembrandt

"The imitator is a poor kind of creature. If a man who only paints a tree, or flower, or other surface he sees before him were an artist, the king of artists would be the photographer."

— *James Abbott McNeill Whistler (1834-1903)*

When you draw apples, depict them geometrically at first. If they have fronts, sides, tops and bottoms, they will be more powerful artistically than spherical apples. The same thinking applies to portraits. Planes are not some artistic sleights of hand. They exist in nature, and squinting will help you to see them. I learned this from Rembrandt, and shortly, you will see how this Cambiaso-like approach, briefly mentioned in chapter 1, can magically lead to a dynamic portrait.

Squinting is important because it eliminates middle tones and distracting details, making it easier to see basic shapes, values and edges, allowing the artist to see the big picture first. Let's say you're painting a forested area like the one behind my house, a confusing mass of vegetation that obscures my neighbors' houses. When I squint, almost closing my upper and lower eyelids, the trees are no longer a jungle. I can see between them and within them triangles, ovals, squares and rectangles. I prefer to concentrate on the rectangles. Instead of painting trees, I paint the shapes, sizes and values of the rectangles and wind up with a convincing interpretation of the scene.

When I squint at the mass of skin and hair that comprises the face of *The Old Jew* in my Rembrandt book (Figure 9.1), I can see the same geometric figures that are visible in the forested area behind my house. Covering the page with a sheet of tracing paper, I trace as many rectangles as I can find. Rembrandt must have squinted at his ancient model and seen geometric figures within his wrinkled face. He must have forced himself to not think about the nose or eyes or lips but only the shapes, sizes and monochromatic values within the rectangles he found on the face. There are dozens of them. The rectangle comprising *The*

*Old Jew's* right eyebrow, the right side of the nose, and the bottom of the cheek is obvious despite the missing fourth side. Some rectangles extend into the background. Some are superimposed over other rectangles. They have a purpose. They delineate planes. I advise you to trace all the rectangles you can find on this painting. Your rectangles may be different from mine. It will be a valuable learning experience.

In a class exercise one day it was easy to find planes on the teacher's angular face and difficult to find them on a student's round one, but I used an "academical" plaster sculpture of a skull for a guide. Simplified planes were on one side, and complicated ones were on the other. On the simplified side, the large planes of the cranial mass and the smaller planes of the facial mass — including the angles and planes of the jaw, cheekbones, brow ridge, chin box, zygomatic arches, eye sockets, nose, ears and barrel of the mouth — were obvious. On the complicated side, the planes of the nose, for example, were broken down further to depict the upper nasal mass and ball of the nose. These planes describe actual surfaces on a face, the front and sides of a chin, for example, which make it appear three-dimensional.

Other planes are invented by the artist. I call them spectral planes. They are purposely made barely perceivable. They are used to connect and relate background to foreground or to de-emphasize lines by crossing them, connecting them to other planes or leading the eye away from them. A portrait shouldn't look as if it were pasted on a background; it should be unified with the background, connected to it by planes, which are often so subtle that the viewer is unaware of them. Early on, finding those planes on masterworks was often maddening. I thought the teacher who told me

to paint them was daft when he went on and on extolling their virtues and encouraging us to incorporate them into our work. Then I did an experiment. I painted three pictures with a complete disregard for planes and three similar ones with as many planes as I could find or invent. Guess which pictures were better?

One day, while strolling down a street in Oakland, California, I saw copies of masterworks through an antique store window and went inside. The proprietor was very proud of the copies hanging on her walls, and she had books on her desk open to prints of the originals. But the poor woman couldn't see any difference between the prints of the originals and the copies on her walls, which she claimed were selling faster than her artist friend could paint them. They ignored even the most basic planes. The copies of Rembrandt's, Ruben's and Sargent's figures were lifeless and morbid, unconnected to the background, with lines that led my eyes astray. I couldn't leave her shop fast enough.

Some artists prefer to paint over old watercolors that have been soaked in water and dried, leaving ghost images. Some paint over old oil paintings that have been re-primed but have traces of lines that go everywhere. How much better it would be if your painting were filled with your fresh lines and planes that go where you want them to go.

## Learning From a Master

On a rainy day at the Hermitage in St. Petersburg, in the Russia from which my mother's family fled to escape religious persecution, a dream came true. I was standing close enough to touch *The Old Jew*, which looked as if it were painted yesterday, not some 360 years ago. It was exhilarating to see my favorite painting in a museum, to see

see the brushstrokes, the thickness of the paint, the glorious tones and colors and nuances. It seemed so three-dimensional that I could have picked the painting up by its nose.

I smelled the fresh oil of artists at work in the museum, copying their favorite works. Rembrandt taught me how to paint. I could almost hear him say, "I'm glad you spend your vacations learning about fine art. It's about time you came to visit my painting, to see for yourself the thick paint, the loose brushstrokes, the paint-knife marks, the brush-handle scratches. I paint with my thumb when necessary."

At home I have a book filled with detailed photographs of Rembrandt's paintings, the ones that live and breathe at the Hermitage. On the green front cover is a gold facsimile of the master's signature. A section about radiographic studies of the great master's work shows places where he painted over passages that displeased him. I've studied and copied many of his portraits, with reverence, because no one can capture inner life better than he can. You must copy the masters! They copied their masters. How else could they learn?

A few years earlier, in my studio in Napa, with the book propped up on a counter, *The Old Jew* said to me, "I dare you to copy my face." I accepted the challenge. I couldn't resist studying the tones of light and dark that melted into each other on Rembrandt's painting. I spent weeks copying the face on an 11 x 14-inch canvas. It prepared me for painting difficult portraits of my own design. Also, the portrait had special relevance. As a child, I met an old man whose job it was to say prayers at graves in Mt. Hebron cemetery in Queens, New York, whether mourners wanted the prayers or not. He said prayers in Hebrew at my mother's grave even though the uncle who accompanied

me could have recited the same ones. The man's eyes were as teary as my aunt's as he prayed for someone he didn't know, and I was moved. I later made him a character in a novel I was writing. *The Old Jew* reminds me of that man who followed us to the gravesite. His shoes clopped on the pavement — loud enough to wake the dead, my aunt said. I wished he would wake my mother. It was important for me to paint *The Old Jew*. I paint only things or people that move me.

I must have been in a trance when I copied that complicated face. I expected to have problems with it, but it wasn't difficult at all. It surely wasn't as difficult as painting a portrait from life. Of course Rembrandt had already perfected the composition, selected the colors, decided on the lighting and solved painting problems for me, some so subtle that they can only be felt rather than seen.

The face of *The Old Jew* is a mass of hair and wrinkled flesh that lends itself to the "connection" approach, mentioned in Chapter One, which provides a high degree of accuracy. Everyone knows that in life it's helpful to have the right connections; it's important in drawing too.

When you draw a face or a figure using this method, squint and look for points on a model that line up with other points. I call these points landmarks, and they don't have to be distinctive. Tips of ears that are not apparent on Rembrandt's painting are landmarks, as is the tip of the chin, which is apparent. Any landmark — the top of an eyebrow, the corner of a shadow, or the edge of a wrinkle of drapery — can be used to locate precisely where things are and how far away they are from something else.

Here's how to proceed: First, practice drawing the face of Rembrandt's *The Old Jew* on a drawing

Figure 9.2. *Old Man*.

pad, making sure the drawing area is the same size as the canvas you will use. With a light touch, mark the points of the triangle connecting the pupils of the eyes and the tip of the nose. There's another triangle, an isosceles one, starting at the top of the nose, its two equal sides cutting through the moustache, in line with the edges of the beard and ending at the base of the beard. The bottom of the triangle is about three nose-lengths from the top of the nose. Compare the sizes and the placement of the two triangles to see if they look right.

Connect other landmarks with straight lines and use a pencil turned this way or that to verify that your lines are angled as Rembrandt angled his. When there are enough marks on the paper to locate the proper placement of eyes, lips, moustache and other facial features, darken the marks you want to keep. Unwanted marks can be erased or painted over, but they should be so light that they're not distracting.

After this important practice session, use charcoal to re-draw the face of *The Old Jew* on a dry gray-tinted canvas and spray it with fixative so the image won't be lost. You don't have to use charcoal, but it's safer because incorrect marks can be wiped out easily with a rag if you're not heavy-handed. These days, I draw with a small brush dipped in lightly tinted oil paint.

What about the rest of the face? How does one make sense of vague shadows, splotches of color and seemingly meaningless marks? (In my opinion, every one of Rembrandt's marks was purposeful, and squinting might make it easier to decipher the marks.) But I did not let color get in the way. It's easier to see values — dark, medium or light — on a black and white image. I copied the picture from my Russian book with a copying machine and drew from the black and white copy.

Over the years, I've done many value studies in black and white. Maybe that's why I enjoy old black and white movies with their dramatic use of lights, darks and everything in between. When copying from a black and white image, or from life, it's a good idea to squint occasionally. Even though the image will be blurred, the shadows will be darker, the highlights lighter, and the shapes and values will be better defined.

When your fixed charcoal image is dry, paint the face monochromatically, using grays made by mixing lead white, burnt sienna, ultramarine blue and a hint of red. Brush on thick, light-colored paint in light areas and thin, transparent, dark paint in shaded areas. The hint of red will keep the painting relatively warm and will prevent the gray areas from becoming too cool when pinkish and warmer colors are added to the skin later. It's painstaking to deal with the slightest nuance of shade, but if you do your homework, you will understand the artistic and philosophic importance of grays.

André Gide said, "The color of truth is gray." When I was young, I thought the color of truth should be black or white, true or untrue, but as I got older, I found more and more gray areas separating truth from untruth. Picasso said, "If there were only one truth, you couldn't paint a hundred canvases on the same theme." He also said, "We all know that art is not truth. Art is a lie that makes us realize truth, at least the truth that is given us to understand. The artist must know the manner whereby to convince others of the truthfulness of his lies."

## Art in Black and White (and Gray)

Grays can be made from black and white and also from mixtures of complementary colors, such as

Figure 9.3. *Little Mervin.*

red and green, purple and yellow, and orange and blue. Grays tend to be cooler or warmer according to how much extra cool or warm is added, and they can be made lighter or darker according to the intensities of the colors. A painting teacher once told the class to randomly select complementary colors from our palettes and puddle them together until some sort of gray was achieved, then duplicate each other's grays. It seemed impossible but was easy if I thought only about warm and cool when I selected colors to match my classmates' grays. Most colorful master paintings have more gray in them than people think, and for vibrancy, the grays are varied. Also, the background is just as important as the foreground, and it's important to let what's underneath show through. Some of those charcoal marks may be needed to lead the eye on a trip through the painting.

When the tonalities and the shapes of the grays on your painting are done to perfection, you will have unity, which is an ordering of all elements in a work of art so that each contributes to a unified esthetic effect. You will have it if you have forced yourself to paint in such a way that the image slowly arose from nothingness like a Polaroid film.

Over the years, I've done many monochromatic under-paintings, and I've not hurried them, because the more time spent, the better the final results were, and when the under-painting was finished, three-quarters of the work was done. When you add color later, your task will be to not break the unified areas into pieces. By using warm and cool versions of the same color, you'll be able to add variety to areas without destroying the unity you've worked so hard to achieve.

I enjoy copying, in black and white, Rembrandt portraits that move me. I advise you to spend as much time as possible copying and learning from monochromatic pictures of the works of masters that move you. Pay attention to the range of grays the artists used. Look for landmarks. Strive for subtlety of line and of value changes, and if you are unable to keep from painting ears, lips and noses, turn the book and the canvas upside down and paint only the tonalities of the shapes you see. When you are done and turn the canvas right side up, you might be pleasantly surprised.

*Old Man* (Figure 9.2) is a portrait of my own design that was influenced by Rembrandt's *The Old Jew*. It was begun with a planar structure of points, lines, angles and rectangles, which I refer to as the bones of a painting. To reach this level, I had to spend a good deal of time copying Rembrandt's work, familiarizing myself with his technique, and expanding my knowledge of anatomy. This painting of my good friend Little Mervin (Figure 9.3) doesn't quite have the Rembrandt look about it but was influenced by the great master nonetheless.

Figure 10.1.

red and green, purple and yellow, and orange and blue. Grays tend to be cooler or warmer according to how much extra cool or warm is added, and they can be made lighter or darker according to the intensities of the colors. A painting teacher once told the class to randomly select complementary colors from our palettes and puddle them together until some sort of gray was achieved, then duplicate each other's grays. It seemed impossible but was easy if I thought only about warm and cool when I selected colors to match my classmates' grays. Most colorful master paintings have more gray in them than people think, and for vibrancy, the grays are varied. Also, the background is just as important as the foreground, and it's important to let what's underneath show through. Some of those charcoal marks may be needed to lead the eye on a trip through the painting.

When the tonalities and the shapes of the grays on your painting are done to perfection, you will have unity, which is an ordering of all elements in a work of art so that each contributes to a unified esthetic effect. You will have it if you have forced yourself to paint in such a way that the image slowly arose from nothingness like a Polaroid film.

Over the years, I've done many monochromatic under-paintings, and I've not hurried them, because the more time spent, the better the final results were, and when the under-painting was finished, three-quarters of the work was done. When you add color later, your task will be to not break the unified areas into pieces. By using warm and cool versions of the same color, you'll be able to add variety to areas without destroying the unity you've worked so hard to achieve.

I enjoy copying, in black and white, Rembrandt portraits that move me. I advise you to spend as much time as possible copying and learning from monochromatic pictures of the works of masters that move you. Pay attention to the range of grays the artists used. Look for landmarks. Strive for subtlety of line and of value changes, and if you are unable to keep from painting ears, lips and noses, turn the book and the canvas upside down and paint only the tonalities of the shapes you see. When you are done and turn the canvas right side up, you might be pleasantly surprised.

*Old Man* (Figure 9.2) is a portrait of my own design that was influenced by Rembrandt's *The Old Jew*. It was begun with a planar structure of points, lines, angles and rectangles, which I refer to as the bones of a painting. To reach this level, I had to spend a good deal of time copying Rembrandt's work, familiarizing myself with his technique, and expanding my knowledge of anatomy. This painting of my good friend Little Mervin (Figure 9.3) doesn't quite have the Rembrandt look about it but was influenced by the great master nonetheless.

Figure 10.1.

## How Sculpting Can Improve Your Painting

"What was any art but a mold in which to imprison for a moment the shining elusive element which is life itself — life hurrying past us and running away, too strong to stop, too sweet to lose."

— *Willa Cather (1873–1947)*

At age 4, I was on my knees with a stick in my hands, bulldozing a highway over the hills and valleys of the bare ground in my cousin's back yard when I came across a lump of clay embedded in the soil. Other lumps were nearby. It felt good to squeeze the cool damp clay between my fingers, to shape it into small bricks, flower pots, animals, and people. No longer interested in highway building, I played with the clay until it was time to go home.

After graduating from dental school, but before studying sculpture, I sculpted my wife's head (Figure 10.1) and mine (Figure 10.2) without any instruction. The heads were easy to do, because I didn't know how. I sawed off 8-inch lengths of wooden rods, the kind used in closets for hanging clothes, and screwed them onto ¾-inch-thick 12 x 12-inch plywood bases. To make the sculptures hollow, I wrapped newspapers around the wood-

en rods and secured them with masking tape. Then I squeezed on many large slabs of clay and reproduced the shapes of our heads. I worked on

Figure 10.2.

Figure 10.3. Bernini's *The Rape of Proserpina*.

the sculptures for three weeks, adding and goug-
ing out clay, and all that time, I felt as I did when
I was 4, living in a wonderland of endless possi-
bilities.

The only technical advice I received was from
a friend who told me to be sure there were no air
bubbles in the clay that might explode when they
were fired in her backyard kiln. When the sculp-
tures were done and sufficiently dry, I pried them
from their plywood bases, twisted out the news-
papers, scooped out the still unhardened clay from
the insides with a big spoon, and five weeks later,
when they were bone dry, I fired the sculptures
in my friend's kiln. They didn't explode. Then,
following her instructions, I spray-painted Ai-
leen's brick-colored sculpture black, then bronze,
then tooth-brushed the deep crevices with a
blue-green powder she concocted that made the
sculpture look as if it had been dredged from the
Mediterranean after centuries of submersion. The
sculpture of myself was left white. I promised my-
self to do better sculptures someday. The eyes on
both pieces did not wrap around the front of the
heads sufficiently, and my friend's dog, apparently
an art critic, chewed off the tip of the nose of the
sculpture of me.

A few years later, as my interest in sculpture
deepened, another beautiful dream came true. At
the Villa Borghese in Rome, I stood close enough
to touch The Rape of Proserpina, sculpted in
1621-2 when Bernini was 23 years old. In fact,
I was so close I could almost feel Bernini's hands
at work. Proserpina's tears are carved into the
marble. Pluto's hand is pressing into her thigh,
making the marble seem as soft as flesh. I was
so enthralled that I kept circling back to the
masterpiece throughout the day, walking around
it again and again (Figures 10.3 –10.4).

Figure 10.4. Detail, *The Rape of Proserpina.*

A general knowledge of sculpture is vital for
understanding and depicting human form. Learn-
ing to sculpt has certainly enhanced my drawing
and painting skills, and I know it will do the same
for you.

### Now You Try It

For an exercise, purchase a large block of gray or
brown clay from an art store, and start with sea-
shells, a scallop for example. Look at its 17 low,
rounded ribs. Feel into the shell as I did with my
scallop, really see the shell, become the shell. This
isn't some hippie-dippy far-out advice. This is
what a sculptor has to do. As you sculpt the bowl,
exaggerate it. The flutings curve to the left and
right and have different shapes, different widths.
Carve deeply into the flutings, because that's
where the dark shadows will be.

Figure 10.5. Bas-relief.

Figure 10.6.

If you liked making mud pies when you were 4, you'll like working with cool, damp, earthy-smelling clay even more. But don't lick the sculpture. If the surface is too smooth it will look as if you actually put your tongue to it. Smooth is okay around the lip, where it's shiny, but not on the outer shell, where you need texture. Try your hand at other types of shells. They're fun to sculpt.

After shells, Joe Query, my drawing and sculpture teacher, had me tackle a bas-relief of the side of a woman's head. You'll find that an old and angular model will be easier to sculpt than one who's young and doesn't have any sharp features to work with. With the young model who posed in Joe's class, I had to use my knowledge of anatomy to hint at muscles that weren't apparent on her face, neck and shoulders. For a reference, I used my dental school book, *Grant's Atlas of Anatomy*.

Here's how I sculpted a bas-relief of Joe's young female model: Starting on a flat slab of clay, I used an ice pick to sketch angles, broadest points and relationships of sizes. As with drawing, I paid attention to "connections" and asked myself a few questions: On the relief, does the curve of the front of my model's neck, if continued upward, connect with the curve of her forehead? Does the angle of the front of her nose, if continued upward, connect with the highest point of her head? Does the shape of her ear repeat the shape of her skull? On most people, the broadest point of the skull is above the hole of the ear and slightly behind it. The next broadest point is anterior to the hole of the ear. I studied the body parts that bring a bust to life — the zygomatic arch, the back of the jaw, the sternocleidomastoid muscle (in men) which is as broad as the back of the jaw. I included the model's shoulder, making sure it extended beyond the broadest part of her skull. Sculpting a few bas-reliefs will prepare you for tackling the entire head. This bas-relief, subsequently damaged in a California earthquake, was my first one (Figure 10.5). An excellent reference for you to use is *Terracotta* by Bruno Lucchesi.

Let's sculpt a solid head that's smaller than life-size. We'll build it around an 8" length of water pipe that's attached to a flange and screwed onto a 12-inch square of ¾-inch plywood. It's ideal to have the sculpture and the model on revolving stands so they can be turned effortlessly. Add clay evenly on both sides, paying attention to the model's profiles without carving down. Remember, a sculpture is 360 profiles. Turn the model every five minutes and give him a break every 20-minutes. Forget about eyes, lips and ears. Joe advised me to slap the clay on, to show it who's boss or it would take over. I used calipers on the model and on my sculpture to make sure the broadest

Figure 10.7. *Demetrios pentahedron.*

points were in the right places and were the right size. Eventually, you won't need calipers. A great reference to use here is *Modeling the Head in Clay* by Bruno Lucchesi.

Your first effort might be as amateurish as mine was, but even if it isn't, tear down what you've done. I know it's hard to do, but as Joe often said, "Don't fall in love with your work. What took you three hours to accomplish today will take only an hour tomorrow." Next day, build up the model's head in clay and double-check the accuracy of the bony landmarks. In side view, the highest point of the top of his head should be vertically aligned with the hole of his ear. The broadest points you already know from the bas-relief exercise. If your friends were sitting on the park bench across the street or were walking a block away, you'd be able to recognize them even though you might not be able to see their features. Of course, their gait, posture and clothing would help. Joe's teacher, the sculptor George Demetrios, was employed by

the U.S. Army Chemical Warfare Service during World War II for his expertise in skull and facial typing. He showed that people can be recognized on the basis of a few bony landmarks. With that knowledge, he developed a "one size fits all" gas mask.

Draw a side view of your model's head. With red crayon, superimpose a pentahedron, with its five sides connecting the highest point of his head, the widest point of his head, the smart bump above the eyes, the corner of his cheekbone, and the angle of his jawbone (Figure 10.7). According to Demetrios, the pentahedron is as good as a fingerprint in identifying a person. When you look at a side-view of your sculpture from the far wall of your studio, does it look like the model even though her features aren't yet developed?

Build up your model's head as you would in a painting, working from the whole to the parts. I emphasize the three-dimensionality of rounded surfaces by making eyelids, noses and chins as angular as possible, which increases their strength. Make sure to wrap the eyes sufficiently around the head. It's helpful to have the light shining on the model be similar to the light on the sculpture. My sculpture of a young man (Figure 10.6) fell off its pedestal during our last earthquake and broke into more than a dozen pieces that I reassembled using silicone adhesive and clay.

Here's a five-minute sculpture I did from memory while waiting to go to lunch with a friend (Figure 10.8). It was refreshing to be able to work speedily without the pressure of having to worry about capturing a likeness. I was especially happy with the placement of the pupils of the eyes, which I made with a pencil point. My friend remarked that the sculpture looked and felt more like her than it would if she had posed for it.

Figure 10.8.

An *écorché* is a manikin that shows muscles and bones that are visible when the skin is removed. (A mannequin is a full-sized model of a complete or partial human figure used for displaying garments.) An écorché is useful for anatomical studies. My hands resemble one because I have CMT, a fairly rare disease that slowly atrophies the mus-cles in hands and feet. I'm in a race against time, but in a larger sense, so are all of us. We would like to create at least one fantastic work in our lifetimes. Leaving morbid thoughts aside, I build up my hand, with gray clay, paying close attention to its proportions, angles and landmarks. As the work progresses, I go from large forms to smaller forms. My hand is easy to sculpt because the muscle atrophy makes the bony landmarks stick out and the planes easy to see.

Here is a white clay study of my wife (Figure 10.9) done from memory. Here she is in another pose (Figure 10.10) also done from memory. It used to be difficult for me to sculpt my right hand in various positions, because I was moving the very hand I was sculpting, but now I'm in the habit of memorizing what I see. I keep my work thin so that clay can be added as needed rather than removed. In *Xenophon's Memorabilia*, Socrates asked the painter Parrhasius how he found models for his beautiful paintings. The painter replied that he chose beautiful noses, arms, and other features from different people and put them together to make a beautiful body. He explained that a composite was necessary because the ideal body

Figure 10.9

couldn't be found in any single individual.

In deciding how to pose models, it's important to know a bit about them, such as their jobs, characters or emotions. You wouldn't want to give a boxer, for example, the pose of a timid man, or vice versa. The whole body must be made to express emotion, not just the face. Contrasting positions of the head, neck and shoulders contribute to a dynamic bearing. The important thing is to have something to say and to use your artistic knowledge to say it well.

Let's sculpt a woman's entire body, 30-inches high. First, we'll make a sturdy framework of thick, but bendable aluminum to support the weight of the clay. A great reference here is *Modeling the Figure in Clay* by Bruno Lucchesi. It's important to establish the posterior chief line, which traces the direction of the head, vertebral column, pelvis and weight-bearing leg. The inside of the anklebone of the weight-bearing leg is under the pit of the neck. Make sure the wire framework is positioned correctly, because it won't do to find out later that wire is sticking through the sculpture on your lazy Susan. Pose the model with her front leg out a bit and her head, torso and pelvis on different planes. This is important! It adds power to any sculpture and to any painting.

Turn the modeling stand and your lazy Susan every five minutes to add clay to the sides of the sculpture that face you. You can't add clay to the front of the sculpture, because there's no way to see how much to add. Remember to stand back often to see the whole and the relationship of parts to the whole. Try to anticipate wrong moves, like laying on too much clay. The sculpture has to be kept thin so more clay can be added later. No carving down. The bony landmarks are your reference points. You must state them accurately in

Figure 10.10.

order to get the proportions right. The more time you spend on each stage, the easier the following stages will be, but don't work in any one place too long. As with a painting, the sculpture should emerge uniformly and come into focus like a developing Polaroid film.

The outside of the model's upper leg is broadest above the center of the thigh; the inside, broadest below center. The upper arms and legs are shorter than the lower ones. The kneecaps face outward. These things aren't always apparent on the model. That's why knowledge of artistic anatomy is important. Joe Query, my teacher, placed dots of talcum powder on models' thighs, calves and breasts, where they protrude the most, to study the heights of convexities in different views. I can imagine myself placing dots of powder on a Bernini sculpture at the Villa Borghese in Rome to study how the fibers of the thick, fan-shaped

muscle of a man's chest radiates from a central point. This radiation can also be seen in leaves, trees and river systems. Our bodies obey the laws of nature.

Art is full of seeming contradictions. Think before you sculpt, not while you sculpt. If you think while you sculpt, the results will look too mechanical. Try to reproduce effects of light and shadow that you see. You may have to deepen triangles of clay or fill in certain areas, but don't destroy the clarity of your composition, which should look balanced from any position. Concentrate on the nuances that will make your work less mechanical. Draw a bent arm in profile view with sharp angles between the deltoid and biceps and between the biceps and supinator muscles. To the right of it draw the same arm with small neutral planes where the sharp angles were. Which arm is more pleasing to look at? The one on the right, because these small planes or rest spaces soften harsh angles and give spring and elegance to forms. They're found on all master works. Try adding these spaces all over your sculptures and your paintings and see what happens.

A worthwhile series of exercises can be done using one of your completed busts, but it has to be done from one of excellent quality. Draw it at eye level, turning the head 15 degrees for each drawing. It might take a while to complete those 24 drawings. Many of your first efforts might wind up in the trashcan, but you'll get better and faster and will be able to state the planes more subtly. Do the same thing looking slightly down on the head. Then do it from a higher angle, a low angle and a lower angle yet. Don't think of the task as drudgery, think of it as a challenge. You'll find that without picking up a brush you become a better painter.

Your paintings and sculptures will improve if you study the works of Bernini and Michelangelo and any master sculptor you admire, but be aware that studying masters who exaggerate reality, too early in your development, may be counter-productive. Here's a bronze sculpture that I own (Figure 10.11) a 33" high grape-picker created by the French sculptor, Henri Louis Levasseur (1853-1934). It's well balanced and looks good from any angle. One of the reasons why I like it so much is that the legs, torso and head are turned in different directions, making it look as if the grape-picker is about to take his next step forward. I pose my models that way too. I've drawn many views of this sculpture, and it has been a great learning tool.

You have to get your hands dirty. Sculpt shells, faces and figures. Read Bruno Lucchesi's books, and you'll want to dig in right away. Everything I learned from Joe, from Bruno and from doing and failing and doing it over again improved my sculpting and painting and drawing, and how satisfied I felt when I eventually got it right. And how satisfied you will feel when you get it right.

Figure 10.11.

Left: Figure 11.1. *Venice.*

## Rearranging Reality

"Every artist dips his brush in his own soul, and paints his own nature into his pictures."

— *Henry Ward Beecher (1813-1887)*

My favorite painting partner is my eagle-eyed friend Julie. We've painted together for years, and I'm always inspired by her work and her wisdom. One evening, at an art exhibit in town, we were looking at my only entry, an oil painting that was done from a photo I took in Venice of a gondola tied up to a building alongside a canal (Figure 11.1).

I had spent an inordinate amount of time on painting everything except the upper left part of the canvas, which I had dashed off in two minutes, trying to meet the deadline for this show. And to my surprise, it was exactly that upper left corner that attracted Julie's eye. She brought the tips of her thumb and index finger together into a circle, and then she looked through the loop of her fingers to study that dashed-off corner of the painting.

"This part is masterfully done," she told me.

"Thank you, but what about the rest of the painting?"

What she told me next was a magnificent lesson.

"The star of the show should have been the gondolier displayed against a contrasting background, which your painting lacks. Yet he's not quite within the 'golden section.' The canvas could be cropped, but it wouldn't be worth the effort. You didn't do a thumbnail sketch first. You painted what you saw instead of rearranging what was there to suit artistic purposes."

Eureka! She helped me to understand the importance of rearranging a scene, not to mention the utter insanity of not doing thumbnail sketches first to solve compositional problems such as placement of figures, tonal contrast, and color harmony.

And what is the lesson here? It is to think before you act, before you spend hours painting a scene that doesn't respect the time-honored principles of composition. My aunt said it best

when I was a child: Haste makes waste.

"Rather than fix it," Julie went on, "I suggest you repaint the entire scene quickly and loosely, the way you painted the masterful part."

How can you not respect a friend who doesn't pull any punches, who tells it like it is, who bases her remarks on her insight of what art really is about, an esthetically pleasing and meaningful arrangement of the scene the artist is driven to paint, painted with strict regard to the language of art.

I sincerely hope you will heed the advice Julie gave me.

## Painting a Grandson

Hanging on my studio wall is a painting of my daughter-in-law Sharon nursing her baby Ryan. As I was taking preparatory pictures of them I was thinking about Renaissance artists' use of putti, pudgy male babies with or without wings who symbolize love, abundance and the personification of human spirit. I wondered how the masters managed to paint them in flight or in any manner of seductive poses.

Putti are important to me. Studying Michelangelo's putti helped me to paint baby Ryan. I made pages of sketches, a few watercolors and a few pastels before daring to paint Sharon and Ryan in oil. After the thumbnail sketch, charcoal drawing and under-painting, I spent a lot of time orchestrating warm and cool flesh tones. Warm colors heighten reliefs, and cool colors give the sensation of depth. This contrast seems to make skin pulsate and be alive. I also concentrated on subtle lost and found edges and achieved an unexpected softness that had eluded me for years.

In order to focus on the baby, I toned down Sharon's face and hands, but her body is stiff, and

I've given her football-player shoulders. Even the way I rendered her collar displeases me (Figure 11.2). So I decided that my next baby picture would be better. I would concentrate on the whole work, not just the baby, and that's my advice for you.

My most complicated portrait to date features Sharon, baby Ryan and his cousin Hayley. I was inspired to do something grand. An empty 30 x 40-inch canvas and a fine gold frame were begging to be put to good use. Composing the picture of Ryan and Sharon was easy, but when I decided to add Hayley to the picture, it was harder to get the most effective composition.

I took photo after photo, in different poses. An arm would look good in one, a head would be pointed the right way in another, the baby's expression was just right in a third but not the arms or hands. So I borrowed parts from several photographs and went to work. Rearranging reality, I narrowed Sharon's shoulders, repositioned limbs and heads, and altered facial expressions, but I left Sharon's hands in shadow so her red fingernails and gold wedding ring wouldn't be distracting. The figures and background are full of "move-the-eye" lines, so the viewer doesn't get stranded anywhere. No line has been drawn haphazardly, they all go somewhere and they relate. Even the brushstrokes relate. Every shape counts, including those of dark and negative spaces. Remember that relationship is what art is all about. The interdependence of all parts is crucial to a successful painting.

Again, I concentrated on edges. The baby's edges are softest, then Hayley's, then Sharon's. Colors and shapes melt into each other. I was completely at peace as I painted, with no time constraints, pressures or interruptions. I wish I

Figure 11.2. *Mother and Child.*

could be in that special space every time I paint. I wish you could be there, too. When the picture was shown, people asked why the mother is not looking at the baby. I had no clever answer until I decided to put a teardrop under the baby's right eye. That was the magic mark. Then I could tell people what Sharon was saying to Hayley: "I knew he'd stop crying if I picked him up" (Figure 11.3).

## Julie's Talking Eucalyptus Trees

The Napa River, as it wends its way through town, can keep artists as busy as they want to be. Julie and I have painted on both sides of the *Third Street Bridge*, which has since been replaced by a tasteless concrete structure, designed and approved by artless, heartless entities concerned only with the bottom line. Three eucalyptus and two pine trees upstream from the old Third Street Bridge dominate the scene. I've tried to capture their grandeur many times but always failed until the day I painted with Julie.

"I wish I could paint trees like you do," I said. "Yours are so ethereal. I can smell the leaves on your canvas and feel the breeze blowing through them. What did you think about when you painted them? Did you squint, forget they were trees, and paint their gestures, or do you have some other method?"

"Maybe this will help," she said. "I think you're the type of person who needs a safety net below you. I don't. An art teacher once told me to leap, and the net would appear. What I advise you to do is to paint what you feel, not what you see. You need the courage to jump into the unknown.

"Here's how I painted those trees," she said.

"Promise you won't laugh: I imagine things, dozens of them, and hardly ever the same ones twice. Sure, I squint. Sure, I abide by the Principles of Composition. Sure, I paint gestures … but the things I imagine take me further from reality where I'm more artistic. In painting the bridge and the trees behind it, I made up a little story: The eucalyptus tree on the right is pointing to the smaller pine, complimenting it on its rapid growth and healthy foliage. The eucalyptus tree in the middle is waiting impatiently for the one on the right to run out of breath so it can speak, and on and on. Make up your own story. Maybe in your story the trees will do a slow waltz. I've never told anyone about my way of seeing things. I don't know why I'm telling you. Consider it a present."

Julie's words — so simple yet profound — led to an epiphany. Her leap of imagination sparked my own. By incorporating reason (the principles of art) and emotion (trees talking) Julie had taken a duality and made it one, enhancing my ability to render reality and deepen my understanding of the painting process at the same time.

I worked on the trees, paying more attention to my story than to the brushwork, and magically, the paint was not drilled onto the canvas (Figure 11.4). Another day, painting with Julie on the other side of the bridge and using her "story" method, I imagined I was the chief architect of my city scene, altering the sizes of the foliage, remodeling light standards on the bridge, even changing the height of the background hills. I was so absorbed in my thoughts that my usual stiff dentist-like approach was repressed. Then I realized that I am the chief architect of any scene I paint, not only The Third Street Bridge (Figure 11.5).

## Another Leap of Imagination

*Trinidad Harbor* (Figure 11.6), north of Eureka, California was painted from a selection of photographs snapped on a cloudless day with a glass-

Figure 11.3. *Mother and Two Children.*

Figure 11.4. *Talking Eucalyptus Trees.*

smooth sea.

Here's what went through my mind as I worked on the scene from start to finish: I've lost the essence of Trinidad. The five photographs clipped to my easel don't evoke the same feelings I felt, observing the scene from the deck of the Seascape Restaurant on a full stomach, with a camera in my hands. There's no fishy smell, no barking sea lions, squawking gulls, creaky pilings, slapping waves. I wish I'd had my easel and paints with me that day, but even if I did, I wasn't comfortable painting in public. And sometimes it's awkward to rearrange reality. So how do I begin? How would you begin?

I take a deep breath and imagine being in Trinidad, California. I can already feel the summer heat and smell the fish. Now for a thumbnail sketch.

With a soft pencil, I draw the pier entering the picture plane obliquely, giving depth. But the horizon is too high. I lower it so that the superstructure of the pier will cut through it. Already my sketch differs from the photographs, but who cares? I'm creating a work of art, not an exact copy of the scene. I make the landmass on the right smaller so it won't dominate the rocks in the foreground. What about the rule of threes? I better add a sliver of land along the left horizon for balance even though there's no land there. Now I have something to work with that feels right. With the side of my pencil lead, I shade the landmasses with three different values. If a fulcrum

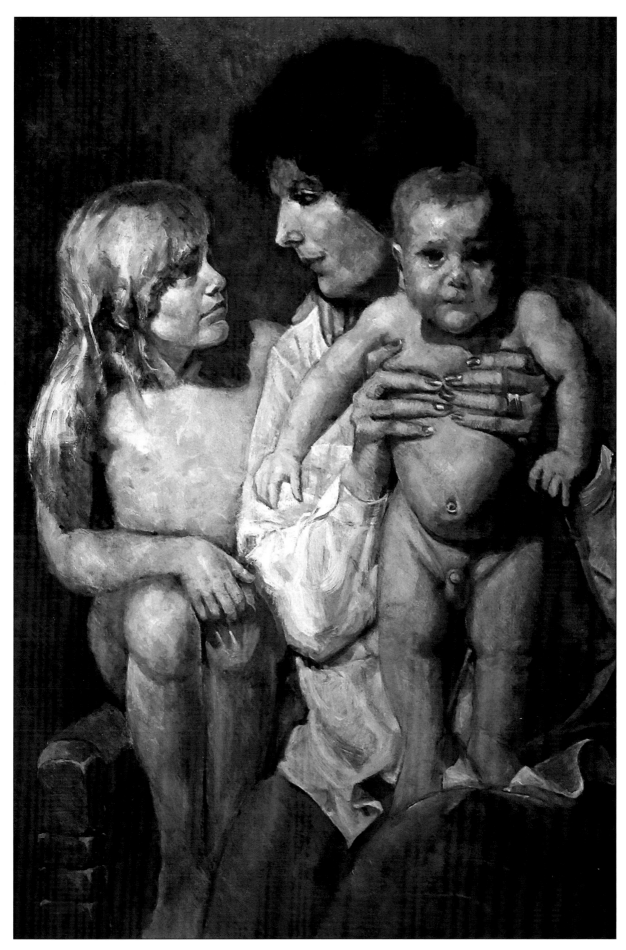

Figure 11.3. *Mother and Two Children*.

Figure 11.4. *Talking Eucalyptus Trees.*

smooth sea.

Here's what went through my mind as I worked on the scene from start to finish: I've lost the essence of Trinidad. The five photographs clipped to my easel don't evoke the same feelings I felt, observing the scene from the deck of the Seascape Restaurant on a full stomach, with a camera in my hands. There's no fishy smell, no barking sea lions, squawking gulls, creaky pilings, slapping waves. I wish I'd had my easel and paints with me that day, but even if I did, I wasn't comfortable painting in public. And sometimes it's awkward to rearrange reality. So how do I begin? How would you begin?

I take a deep breath and imagine being in Trinidad, California. I can already feel the summer heat and smell the fish. Now for a thumbnail sketch.

With a soft pencil, I draw the pier entering the picture plane obliquely, giving depth. But the horizon is too high. I lower it so that the superstructure of the pier will cut through it. Already my sketch differs from the photographs, but who cares? I'm creating a work of art, not an exact copy of the scene. I make the landmass on the right smaller so it won't dominate the rocks in the foreground. What about the rule of threes? I better add a sliver of land along the left horizon for balance even though there's no land there. Now I have something to work with that feels right. With the side of my pencil lead, I shade the landmasses with three different values. If a fulcrum

Figure 11.5. *Third Street Bridge.*

Figure 11.6. *Trinidad Harbor.*

were placed under the sketch, the darks and lights and the weights of the masses would be in balance.

With a small round brush dipped in a watery mix of burnt umber, I redraw the sketch on canvas and under-paint the land, rocks, sea and sky, but I realize I have to do more rearranging. The sea is bland, so I rough it up with waves and froth, and I create a subtle map of the world in the sky with clouds as continents. The scene is no longer bland, but I have misgivings about the map. Did I see it years ago in a painting at the Met? It's a moot point, because if I leave it in, Trinidad will be less important. So I paint a new sky full of subtle planes that connect with planes in the water to guide the eye like a subway map guides passengers. My routes lead the eyes to the pier. My job now is to make sure the viewer won't be stuck there.

I had thought the verticality of the pilings would neutralize the horizontality of the deck, but the pier dominates by virtue of its size and structural detail. So I enlarge the fishing boat a number of times so that it distracts attention from the pier. Now it occurs to me that aside from the pier and the fishing boat, the landmasses and the clouds are more or less rounded, so I paint several subtle arcs under the pier and an even subtler one over it. This softens its impact and makes it relate to the rest of the picture. Problem solved. Sea, sky, landmasses, boat and pier are interlaced with planes that support the painting and hold each piece in place like a jigsaw puzzle.

When the completed painting was hung in my office, my dental assistant noticed that the foreground rocks resemble two elephants. That was not my intention. What she didn't notice, and she wasn't supposed to, was the way I had controlled eye movement by using the elements and principles of composition to best advantage.

Figure 11.7. *Cliffs of Moher.*

My advice is to never neglect the basics.

Another original seascape is *The Cliffs of Moher* (Figure 11.7) in County Clare on the west coast of Ireland. Standing on the overlook the day I was there, I snapped a few photos of a scene that I thought could not possibly be improved upon.

At home in Napa, I was able to salvage only one over-developed transparency of the cliffs, which I brought to a photography shop in Napa (in those pre-digital times) to get under-developed. There was enough information to compose a number of thumbnail sketches before painting the cliffs with their subtle nuances of color and shade. As the cliffs receded into the distance, they became smaller, cooler and fuzzier. The color, texture and forms seemed to ooze out of my brush magically.

But art is not photography. The scene still needed subtle "move-the-eye" marks to guide you through the painting. I also had to rearrange "dis-tractions," the different intensities of light where the waves crash against the cliffs, pulling your eyes away from the cliffs but allowing you to return.

I didn't paint people on top of the nearest cliff, which is almost 700 feet high, because they were the size of ants. A Figure in the foreground would have been too much of a distraction, but a few gulls could have added to the scene.

A fisherman and a climber were included in Figure 11.8 to give *Rock Climber's Challenge* a sense of dimension. It wasn't until press time that I noticed a face at the top left of the cliff. It certainly wasn't placed there on purpose. I've seen faces in masterworks in museums, and I don't know if they were accidental or purposeful, but it doesn't matter as long as the paintings convey feelings.

Figure 11.8. *Rock Climber's Challenge in Trinidad.*

## The Golden Rectangle

My teacher Bill's class assignment one day was flower-painting. I told him that flower painting didn't interest me.

"That's all the more reason to paint them," he advised. "You'll learn about subtlety from flowers, and you'll learn about the rearrangement of reality."

Margaret, a fellow student, picked wildflowers in the field across the road, and the class struggled with how to arrange them. "Look how I've arranged this shallow vase," Margaret said later. "The flower clusters are large, medium and small, the stems are short, medium and tall, and the distances between stems and clusters also adhere to the rule of threes. Composing is easy when you follow the basics."

After painting a few arrangements, I wanted to take flower-painting to the next level and incorporate planes and the golden rectangle. And what better teacher was there for flower painting than Manet?

In my Manet book, I found his *Pinks and Clematis in a Crystal Vase*, which hangs in the Musée d'Orsay in Paris. I copied it, and every brushstroke felt right. What holds the painting together is the large golden rectangle of pink flowers, the rectangle of the vase, the smaller green rectangle within the vase and the rectangle of the clematis. The book said that the flowers were placed in the vase with no concern for their arrangement. I disagree. I believe every mark on Manet's canvas was planned to the nth degree. The single violet-colored clematis lies within the golden rectangle and harmonizes with the blue-gray background. The green leaves vary in size and distance from one another. The shapes of the background negative spaces are different. Other geometric shapes can be imagined in the background, unifying foreground and background. This copy has been hanging on my wall for years, and it's always a joy to look at (Figure 11.9).

Figure 11.9. My copy of Manet's *Pinks and Carnations in a Crystal Vase*.

Figure 11.10. *Chrysanthemums.*

I had a bit of trouble with my original painting of Chrysanthemums (Figure 11.10), which has stood the test of time on my bedroom wall. I was always very hesitant — even afraid — to paint flowers. Chrysanthemums seemed more difficult to capture than roses. I could see a single rose, even the individual petals, but chrysanthemums have so many petals they're confusing, and painting them seemed like an impossible task. I put four chrysanthemums in a vase, arranged them, and wondered how to proceed. I knew better than to paint every petal or even to think of them as chrysanthemums, but only as light, dark and middle tones. I also knew that flowers shouldn't all point the same way, so I tilted them.

I squinted at the flowers and saw a rectangle around them, rectangles to demark them, rect-angles around the green leaves, even rectangles inside the individual chrysanthemums. Then I painted the tonalities of my composition, and the chrysanthemums magically appeared, but I had to subdue the vase yet also give enough attention to its circular shape so the viewers' eyes would move away from the vase and come back to it again. What's the lesson here? To never neglect the geometry, the bones of the painting.

Painting a photographic copy of a scene is time-consuming. A camera can do the same thing in a second. And both methods will rarely, if ever, satisfy the principles of fine art. A rearrangement of reality is almost always necessary. Of course, the innermost feelings of the artist must be built into that rearrangement.

Figure 12.1. *Me, at the bridge table.*

## Soaring

"Every portrait that is painted with feeling is a portrait of the artist, not of the sitter."

— *Oscar Wilde (1854-1900)*

Sooner or later, if you're inquisitive enough, you'll figure out portrait painting problems for yourself, and when you do, you'll feel like a bird, soaring in an updraft, hardly ever flapping a wing. But soaring doesn't come easy, and neither do portraits.

I've always wanted to capture the look on a person's face, like thoughtfulness, weariness, unpretentiousness. When I study my best paintings, those of my wife Aileen, my daughter Kathy (who we'll meet next chapter) and Daphne, my Nefertiti model, I see many things: wisdom, contemplation, caring, a touch of mystery. But these are after-the-fact observations. I don't know how I managed to capture those qualities. I didn't plan them. I painted the feelings the women engendered in my heart, and the qualities appeared on the canvas as if by magic. I often paint something without knowing how I did it. Or maybe I did know without realizing it. Did I learn about emo-

tion from the cartoons I drew as a kid?

I read the funnies every morning before I solve the crossword puzzle and the sudoku. I know what Dagwood is thinking or feeling before I read the words in the bubble. Good cartoonists are experts at conveying emotion, not only by contorting eyes, eyebrows and mouth, but also eyelids and facial skin. Log on to (https://www.youtube.com/user/DrawWithJazza) and watch Josiah Brooks' tutorial on how to draw emotional qualities: contented, happy, angry, sad, serious and cunning faces. Then use this information to imbue your portraits with the appropriate emotions. Often, tweaking a lip a millimeter or two will result in a noticeable change of emotion.

I've done many self-portraits over the years. Whether I paint from a photo or from a mirror, the result is almost always a somber face. Figure 12.1 could be me at the bridge table, about to trump my opponent's ace. Figure 12.2 could be me as a

Figure 12.2. *Me, on the range.*

Figure 12.3. *Me, when the Oakland A's lose.*

Figure 12.4. *Me, elongated and Expressionistic.*

Figure 12.5. *Me at the opera house.*

cowboy, dreaming of the open range. Figure 12.3 is almost in tears: the Oakland Athletics have been eliminated from the pennant race. Figure 12.4 is elongated and distorted, painted in an Expressionist style. Figure 12.5 is me at the opera house being nudged awake by Aileen. The picture on the back of the dust jacket is the real me, neither happy nor sad, just someone contemplating art. When Aileen wanted to photograph me as I was painting it from a mirror image, she asked me to smile. I told her, "I am smiling."

### Painting a Mentor and Monster

The hard work began when I gave myself an assignment — painting the good and the not so good aspects of a person in one portrait. The subject was my teacher, Bill, who died of Camel poisoning years ago, having smoked four packs of cigarettes a day for most of his life. He was a stubborn, slovenly, irascible, bigoted ex-prize-fighter, a survivor of Guadalcanal — and malaria — in World War II, an alcoholic genius who could read Nietzsche in German, play the piano, compose music, write songs that he sang with a lilting Irish tenor while accompanying them on his guitar, paint incredible landscapes, teach art like no-one I have ever seen or heard about, and sometimes behave like the devil himself.

I didn't have a decent photograph of him, just a few quick sketches from when he posed because a model wasn't available. I wanted to paint his prejudice, intolerance and pride and in the same portrait depict him as a brilliant, inspiring, yet troubled genius who also had the patience of a saint. Doing that in prose or poetry would have been easy, doing it in paint, much tougher. I had to ask the masters for help. I hope you ask the masters for help when you have a painting problem.

Looking through my art books, I found a self-portrait of the painter Lucian Freud. He could have been Bill's twin brother — tough as nails, no nonsense, not someone you'd want to trifle with — but I didn't want to copy Freud's portrait and call it my own. There was an Expressionist portrait of the art critic, Julius Meier-Graefe, by Lovis Corinth, which looked tough but also reflective, with more dimension than Freud's work, in my opinion. I liked the somber colors and the loose brushwork.

Beyond those, I thought I'd see what my pal Rembrandt had to say. The Self-Portrait at the Age of Thirty-Four, with Rembrandt's forearm resting on a ledge, had warmth and softness, but it was too handsome, too friendly. It wouldn't work as a model for Bill's portrait, yet the large right hand suggested power, and the facial expression said, "I'm sure of myself." Bill was certainly sure

Figure 12.6. Rembrandt *Self-portrait*, 1658

Figure 12.7. *My mentor, Bill King.*

of himself! Rembrandt's Self-Portrait from 1655, a straight-on view, had kind eyes, but the lips said, "Don't mess with me." I liked the mixed messages. Bill's demeanor gave me mixed messages, too. Jan Six, Rembrandt's friend, was portrayed as dapper, intelligent, impatient, maybe a little worried. More conflicting messages. Also, Bill was far from dapper.

Rembrandt's *Self-portrait* from 1658 (Figure 12.6), painted when he was 52, called out to me. Years ago, I stood in front of that larger-than-life masterpiece at the Frick mansion in New York, looking up at a self-assured Rembrandt with intelligent eyes, capable hands, lips about to point out

in a kindly way some phrase that might illuminate my artistic path. I looked up to Bill too. His lips often uttered a disparaging remark, but my path was illuminated nonetheless. I abhorred his racism and intolerance, but as a teacher, his gifts outweighed his flaws. The Frick painting with its warmth and the golden glow of Rembrandt's tunic was magical. And the lips and especially the eyes were what made it work for me.

After the thumbnail sketch, I drew Bill's figure on my canvas in oil, then scrubbed out the hand and arm positions and re-drew them a few times until I was satisfied with the pose.

I bent the ends of his eyebrows upward, exag-

gerated his widow's peak, captured his hellish nature by giving him an evil sneer and a suggestion of horns nudging their way through his hairline. It was fun to soar and be on the verge of having painted a portrait worthy of signing. Then common sense prevailed. I couldn't have done what I had just done without Bill's patient tutelage over the years. He wasn't the devil, I was, at least that day. Bill was an angel in disguise, and he needed respect, not mockery. It wasn't ethical for me to use my artistic gift for unsavory purposes.

So I scrubbed out my devil-like portrait and re-drew a kinder, more caring Bill. I elongated his face only slightly, and I exaggerated his capable prize-fighter's hands, because they were what defined him. He couldn't have uttered a word without them, once gesturing so broadly that he knocked a full cup of coffee off the kitchen table. I made each eye different so the viewer would know which one to look at first. The brown eye that saw through me the first day we met at a college drawing session was made brighter, the other eye, dreamier, perhaps looking inward at an area

of a drawing that could be improved. I made one side of his lips pinched and conceited, ready to chastise a student for some artistic sin; the other side, not quite smiling, ready to offer an encouraging word. The hand in the light, brandishing a pointed brush loaded with paint, is ready to bring a student's painting to life. The hand in shadow, squeezed into a fist, is ready to be shaken at anyone foolish enough to bad-mouth Rembrandt.

Figure 12.7 is an alla prima study of Bill, a painting usually done from life in one session. This preliminary oil sketch is far from finished. It needs a lot of refining. The face and the hair are not fully developed. Bill was older and wrinkled, with a hovering posture and an ever-present cigarette between his lips. The real Bill, with his leathery skin, could have been cast as the ideal movie gangster. This Bill is bland, unemotional and unconvincing. It looks more like me than him. I should have quit after my first devilish portrayal. I was all fired up then, and soaring was easy. This rendition was forced, artificial, and wasn't driven by a great urge. My advice to you: Don't paint when you're

Figure 12.8. *Me, drawn by Bill King.*

Figure 12.9. *Self-portrait.*

not fired up, as Bill was when he drew me as I was drawing a model (Figure (12.8).

Here's a self-portrait (Figure 12.9) I roughed-in one evening after spraying the charcoal sketch with fixitive. I like the monochromatic under-painting just the way it is and hesitate to add color or change it in any way. I had that soaring feeling as I was painting it, and who's to say but me that it isn't a finished painting? It was done without thinking about the principles of art, the rules of three, or any of my procedural lists. I've reached the point where those things are part of me now. I've also reached the point where I can decide for myself when a work is done.

Figure 13.1. *Pensive Model*

The Courage to Create

"Unless you go beyond what you have already mastered, you will never grow."

— *Ralph Waldo Emerson (1803-1882)*

We have come a long way together, you and I, and as I bring this book to a conclusion, I'd like to summarize my own journey in art and draw out a few final lessons that I hope you can use in your own work.

Let me begin with *Pensive Model* (Figure 13.1), a portrait that I painted in six weekly six-hour sessions. As I was painting the model, I imagined myself posed peacefully in her comfortable chair, lost in thought. I was taught to always imagine myself in the model's pose. But I couldn't have painted this portrait without sage advice from my teachers, years of practice, plus trashcans full of failures. Of course the woman I've painted looks introspective. Doesn't the painter paint himself?

Every artist needs a hero, some master painter to look up to and emulate. My hero is Rembrandt. By studying and copying his work, I've learned how to convey feelings. The conveyance

of feelings encompasses everything I've written in this book. But I can't convey feelings unless I'm inspired, unless I'm all fired up. You will need someone or some thing to light a fire under you. Rembrandt lights one under me. I'll show you what I mean.

Years ago, I met the love of my life at the Tate Art Museum alongside the Thames in London. It was cold, windy, and rainy, and I ducked into the Tate to warm up. I met her in one of the galleries. She was wearing a long white dress with a deep V neckline, and she was as wet as I was. She had auburn hair with curls tucked up over the back of her head. I felt like reaching out and holding her. She was busty without being lusty, looking down demurely as if she had lost an earring on the museum floor. She wasn't ugly or beautiful, tall or short, fat or thin, but everything at once. Her charm was in her softness, her gentleness, her innocence, her enigmatic smile. Her skin glowed.

She pulsated with life. She warmed the air around me, and the soul within me.

How's that for conveying feelings? Rembrandt's mistress Hendrickje, who modeled for the portrait, could have stepped right out of the canvas. She was painted with spontaneity and passion. I visit Rembrandt's *A Woman Bathing in a Stream* (Figure 13.2) whenever I'm in London.

I hope you find a work of art that has a similar effect on you.

• • •

I've also learned a lot about art the hard way. I have made terrible mistakes, hundreds of them, but I always tried to make them into learning experiences. Today, I seldom make the same mistake twice, except for not always doing thumbnail sketches, which is unforgivable.

Another way to learn is to adopt what Zen

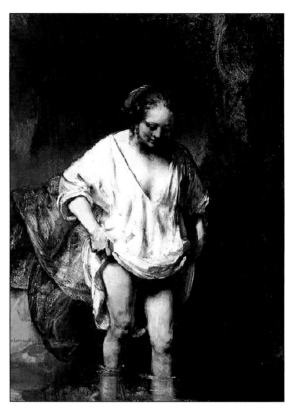

Figure 13.2. *Rembrandt's Woman Bathing in a Stream.*

Buddhism calls a "beginner's mind." Regardless of what level of expertise you have reached in art, you must be able to let go of preconceptions, open your mind to new ideas and study a subject like an eager child learning something for the first time.

I learn best when I'm challenged. My daughter Kathy gave me an old photograph taken when she was 17 (Figure 13.3). I liked her spaghetti-strap dress and her youthful innocence but not the engulfing chair, the awkward pose, the hidden left hand, the uncomfortable-looking right arm and the pronounced collarbones.

Figure 13.3. *Photo of Kathy*

After studying the photo and making a few sketches, I changed the back of the chair, the cushions and collarbones, altered the arm positions and introduced the interplay of warm and cool to add life and sparkle (Figure 13.4). I've learned that photos are just color guides and memory tweakers, not pictures to be slavishly copied. It was fun to rearrange reality.

As a case in point, here's an unfinished portrait of my mother (Figure 13.5) painted from a tiny photograph taken on a sunny Manhattan sidewalk in the 1930's, before I was born. In my thumbnail sketch I left out the buildings, store fronts and vintage autos. I wish I could find a similar dress so I could capture the colors. I was told that the ribbon was most likely green or blue. Some day I'll finish this painting, using my oldest

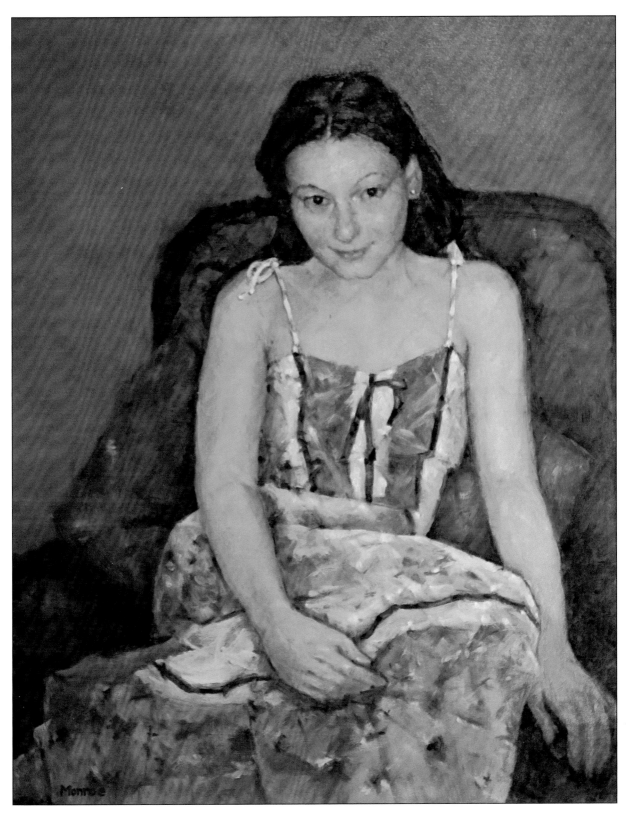

Figure 13.4. *My portrait of Kathy.*

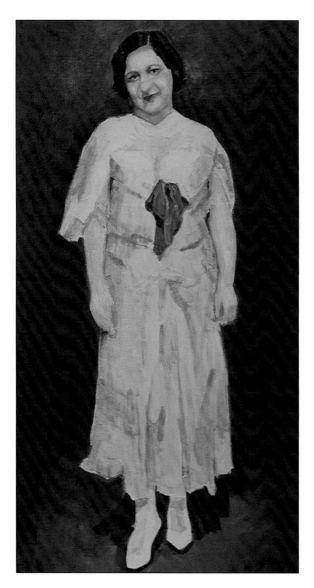

Figure 13.5. *Unfinished portrait of my mother.*

daughter Minette as a model. Here's Minette, who sat for this portrait when she was 25 (Figure 13.6). I reversed the light falling on her hands. It's nice to be able to change what's there, to alter the truth for artistic purposes.

If a subject is too busy or disinclined to sit for hours, I'll gladly take several photographs and paint from the best one. If the subject is unavailable, I ask for photos to be taken with ideal unidirectional lighting from above. But most of the time, people want me to paint from old photos

that are unsatisfactory because of poor lighting, awkward poses, or insufficient clarity. Yet, I enjoy the challenge of painting from old photos.

I was honored when composer and pianist Richard Evans asked me to paint his portrait. Since posing for a painting, or photographs, was not an option because of his busy schedule, I was sent a number of photographs, none of which suited me. No problem. I could choose different parts of several photos, put them together, and then fake the lighting and shadows.

My preliminary sketches and composition were going well. I took a picture of my roughed-in painting and showed it to Richard's wife Deborah at a concert. She wondered why Richard wasn't smiling. She said his smile is his trademark. Well, I didn't want to disappoint her, so I happily accepted the new challenge, even though I had never painted a person with teeth showing. Yet I managed to produce a painting depicting Richard at a dress rehearsal, smiling broadly and joyfully playing the piano. Next page. (Figure 13.7).

I've heard artists complain that when they paint to please the sitter or the sitter's family, their work is not as loose and free as when they paint to please themselves. But when restrictions are placed on me, I don't lose inspiration and emotional connection. Instead of the fire going out, it blazes.

## Heart to Heart

At a local production of *La Traviata*, I snapped a few pictures of the diva in her glorious costume and painted this study in oils (Figure 13.8). Her lips were apart, but I suggested her beautiful teeth rather than paint them in detail. I learned this power of suggestion from Sargent, whose portrait of *Madame Gautreau Drinking a Toast* (Figure 13.9) can be seen at the Isabella Stewart

Figure 13.6. *Minette.*

Figure 13.7. *Portrait of Richard Evans.*

Figure 13.9. Sargent's painting, *Madame Gautreau Drinking a Toast.*

Figure 13.8. *Opera Singer.*

Gardner Museum in Boston. While not as famous or notorious as the painting of Madame Gautreau in the Met, known as *Madame X*, this portrait drove home the importance of close tonal contrasts in painting flesh and the importance of subtlety and delicacy in suggesting hands, flowers and the light gray organdy wrap covering her décolletage. Sargent's painting enchanted me.

A source of painterly inspiration is my list of dental patients waiting their turn for a portrait. Helen, the patient who posed for *Woman in Wig and Dashiki* (Figure 13.10) left the garment with me so I could paint it at my leisure. The built-in "move the eye lines" gave me an added appreciation of the art of design. Helen's hand would have

been lost if its background weren't dark.

*Woman in Tuxedo* (Figure 13.11), although more of a fashion magazine illustration than a serious work of art, was also a lesson in subtlety. Notice how the hair and hand are handled. Every painting is a lesson and a challenge.

Another source of inspiration is the daily *San Francisco Chronicle*. I've copied pictures of racehorses from the sports section, exotic cityscapes from the Travel section, and this picture of famous conductor Seiji Ozawa from the Arts and Entertainment section (Figure 13.12) that I've transformed into a humorous caricature. The aim of this study was to portray motion, and I succeeded by fuzzing out the hands and the baton. A fire was under me the whole time.

These days, my lines are less drilled, less dentist-like. Yet some of my work consists of masking the footsteps of work, making the difficult passages that I struggled with seem free, unforced, as if the brushstrokes were laid down rapidly without having to think about them. I'm not there yet, nor will I ever be, because there will always be more to learn.

I turned 80 in the course of writing this book. I never expected to do a book on art, but one day I realized that I had something important to say about art, and I wanted to share it with others, especially with my granddaughter Tiffany. She has all the makings of an artist, and I wanted to help her on her way — just as I want to help you. But how do you teach people to explore and use their creativity? In the end, I decided the only way I could do that was heart to heart, by sharing my own journey in art, with all of its ups and downs, and all of its multiple tortures and joys. My hope for her — as it is for you — is that my journey in art will help throw open the doors to a life filled

Figure 13.10. *Woman in Wig and Dashiki.*

Figure 13.11. *Woman in a Tuxedo.*

Figure 13.12. *Portrait of Seiji Ozawa.*

with meaning and purpose and, ultimately, filled with the deepest sense of personal fullfillment.

One last thing. When I began studying art, it seemed that all the other students were better at it than I was. Faster, too. And no one else seemed to fall on his face as much as I did. Then one day our drawing teacher singled out one of my drawings and sang its praises. Suddenly, all of my past failures miraculously disappeared, and I felt like a million bucks. And from there, encouraged, full of fire, I poured myself into art with even more fervor, and I was able to create the array of drawings and paintings that I have shared with you in these pages. And along the way, I learned the most important lesson: A real artist never stops learning, never stops growing, never stops going beyond what he has already mastered. So stay positive. Stay open. Stay hungry for more. And if you ever get discouraged or bogged down, the great masters are there to help, and to answer, all of your questions. They are waiting for you in your local library, in museums, on your bookshelves, on your own computer. Visit them often. And don't ever worry about finding your true, authentic artistic voice. It will find you.

## Acknowledgments

My thanks to these good people:

Joan Katz, my wife and always my first reader, who has great skill at trimming away non-essentials and then distilling out the true essence of what I want to say.

Alan Skinner, who did most of the photography, handling each piece as if it were a precious jewel.

Marcus Eliason, who suggested that I write a book dealing with the creation of art, thus setting me off on this great adventure.

Paul Chutkow, my friend, publisher and mentor, for his patience and his matchless guidance from beginning to end.

A. Cort Sinnes, my first book designer, and also a painter and writer, who went beyond the call of duty and established the proper tone and template for this book.

Dorothy Carico Smith, who gave the text, photos and dust jacket their beautiful, uplifting finish.

31192021603533